TEXAS WOMEN FIRST

LEADING LADIES OF LONE STAR HISTORY

Sherrie S. McLeRoy

THE
History
PRESS

Published by The History Press
Charleston, SC 29403
www.historypress.net

First published 2015

Manufactured in the United States

ISBN 978.1.62619.714.5

Library of Congress Control Number: 2014953384

To Bill, always.

CONTENTS

Author's Foreword 9
Acknowledgements 11

1. Aeronautics 13
2. Arts and Entertainment 19
3. Business and Industry 41
4. Education 53
5. Food and Drink 73
6. Government 79
7. Legal 93
8. Literature 101
9. Medical 109
10. Military 123
11. Natural 129
12. Ranching and Farming 137
13. Social and Religious 151

Notes 163
Bibliography 171
Index 183
About the Author 189

AUTHOR'S FOREWORD

I hope you enjoy this brief look at some of Texas's women of achievement. Many books have been written on the subject in recent years—perhaps you will be intrigued enough by the sketches here to learn more about them or to visit museums and historic sites associated with them.

In selecting entries, I have chosen a mix of famous, not so famous and "I've never heard of her." And finding photographs or images of some of these ladies has been a challenge! A few are represented only by a photo and caption, not because they're unimportant but because of word and space limitations.

A few words about Texas history: it's big, and it's complicated. "Six Flags over Texas" doesn't just mean amusement parks; those flags actually represent the countries or entities that have laid claim to this land since the sixteenth century. For example, Texas was Spanish far longer than it has been American. Here's a quick rundown: Spain, France, Mexico, Republic of Texas, Confederate States of America and United States of America.

Discover these leading ladies of Texas!

SHERRIE S. McLEROY

Acknowledgements

S o many people have helped make this book possible, giving generously of their time and knowledge to help me find elusive facts and photographs. Thank y'all so much—I would have torn out a lot more of my hair without you! (Listings are alphabetical by institution.)

Dennis Miller at the Abilene Public Library; Geoff Hunt at Baylor University's Texas Collection; Margaret L. Schlankey and Aryn Glazier at the Dolph Briscoe Center for American History; Heather Castagna and Amanda Rush at the Doss Heritage Center in Weatherford; Danny Gonzalez at the Borderlands Collection of El Paso Public Library; Betty Shankle—again!—in the Genealogy/Local History Department of the Fort Worth Public Library; Pat Mosher at the Gonzales County Archives; Michael Gilmore of the Harry Ransom Center at the University of Texas; Timothy Rouk and Joel Draut at the Houston Metropolitan Research Center; Patricia A. Wilkins at Huston-Tillotson University in Austin; Sarita B. Oertling in the Moody Medical Library at the University of Texas Medical Branch (who turned out to have been a fellow staffer at Galveston Historical Foundation); J.P. McDonald at the Museum of East Texas (who turned out to share a birthday with me!); Kate Igoe at the Smithsonian's National Air and Space Museum; Phyllis Earles at Prairie View A&M University; Ron Vinson at the Presbyterian Heritage Center in Montreat, North Carolina; Robin Shackelford at the Rockwall County (Texas) Historical Foundation; Travis Bible at Galveston's Rosenberg Library and Galveston/Texas

History Center; Kathy Daniels at the University of Michigan's Sindescue Museum of Dentistry; Tiffany Wright at the Smith County (Texas) Historical Society; Caitlin Bumford at the State Bar of Texas Archives; Pilar Baskett and Robin W. Arnold at Texas A&M University Libraries; Ryan Grammer at the Texas Horse Racing Museum and Hall of Fame in Selma, Texas; Sherlynn Kelley at the Texas Sheriffs' Association; John Anderson at Texas State Library and Archives; Liz Ballard at the Texas Rose Festival Association; Mollie Moore Chapter (Tyler) of the United Daughters of the Confederacy; Dreanna Belden and University of North Texas Libraries; Deidre Martin at the University of South Carolina–Aiken; Dayna Williams-Capone at the Victoria (Texas) Public Library; Elizabeth Higgins and Julie Ledet at the Witte Museum in San Antonio; the Archives and Library at the Woman's Club of Fort Worth; Bethany Ross and Kimberly Johnson at the Woman's Collection of Texas Woman's University; Ann Bleiker at the Women's Professional Rodeo Association; Cathy Spitzenberger—again!—at the Special Collections Department of the University of Texas–Arlington; and Tom Shelton at the University of Texas–San Antonio/Institute of Texan Cultures.

Chapter 1

AERONAUTICS

YOUNGEST WOMAN IN THE WORLD TO RECEIVE AN AIRPLANE PILOT'S LICENSE: MARJORIE STINSON (1895–1975)

Flowing brunette locks, demure ruffled dresses and a sweet expression gave no hint of the steel that drove Marjorie Stinson to great heights as a pioneer aviatrix.

Her role models were elder sister Katherine, who became the fourth American woman to earn a pilot's license (1912), and their adventurous, modern-thinking mother, Emma Stinson. The two led the family from Alabama to Hot Springs, Arkansas, where they opened Stinson Aviation Company. In 1913, the Stinsons moved to San Antonio, Texas, drawn by its good weather and the beginnings of American military air service there, and established a flight training school. The following year, Marjorie, only seventeen, traveled alone to Dayton, Ohio, to train at Orville and Wilbur Wright's school. The Wrights took one look at the young woman and demanded her mother's written permission first. Forty-eight days later, she became the ninth American woman and the youngest in the world to earn her wings. Marjorie joined the Stinson family firm as a flight instructor at a time when relatively few American women were "in business" and none could vote.

War broke out in Europe in 1914, and armies were in need of pilots for new aeronautical combat. In the first few years of the war, Marjorie

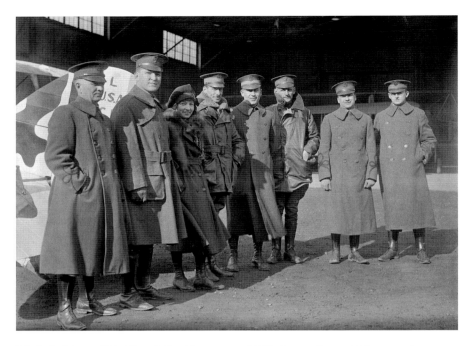

Marjorie Stinson (third from left) with a group of U.S. Army officers visiting an unknown airplane hangar in 1918. *Photo LC-H261-29956, courtesy of Library of Congress Prints and Photographs Division.*

trained at least one hundred cadets who later joined the British Royal Flying Corps or the U.S. Army Air Corps. Her students nicknamed her the "Flying Schoolmarm" and proudly called themselves the Texas Escadrille.[1] In 1915, she was named the first and only female member of America's Aviation Reserve Corps.

Marjorie also traveled the air show circuit, thrilling crowds with Waldo Pepper–style stunts that sometimes failed; in a 1916 event, her plane fell one hundred feet, and rescuers had to pull her "from the heap of blood spattered splinters."[2] In another act, Marjorie dropped sandbag "bombs" onto simulated warships. An ardent suffragist, she also frequently airdropped right-to-vote literature in towns she visited.

In 1928, she left professional flying to become a U.S. Navy aeronautical draftsman. She also helped organize the Early Birds Club, composed of pilots such as Fokker, Sikorsky and Marjorie herself who began flying before December 17, 1916. Marjorie retired in 1945 and spent the rest of her life researching a book on the history of aviation. She never completed it.

The Flying Schoolmarm died in 1975. Her ashes were airmailed back to San Antonio and dropped over Stinson Field, the site of the family's school.

FIRST BLACK PERSON IN THE WORLD AND FIRST TEXAS WOMAN TO BE LICENSED AS A PILOT: BESSIE COLEMAN (CIRCA 1892–1926)

"We used to pick cotton in Texas," Bessie Coleman once said, "and I'd look up and think, 'If we're going to better ourselves, we've got to get above these cotton fields.'"[3] And she did—as high above them as a person could go in those days.

One of thirteen children, she was born in 1892 or 1893 in Atlanta, Texas (southwest of Texarkana), and the family soon moved to Waxahachie (south of Dallas). Bessie was seven when her mother, Susan Coleman, refused to accompany her father, of mixed Choctaw and African American blood, to the Indian Territory (Oklahoma). Coleman and her children picked cotton and took in laundry to survive. Although illiterate herself, the mother ensured that

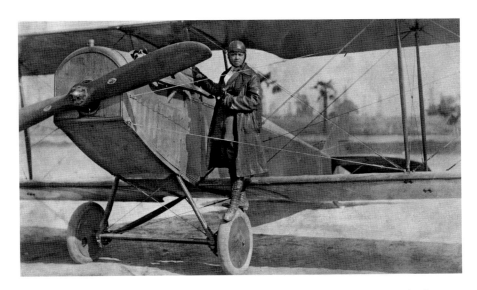

Bessie Coleman with her Curtiss JN-4 ("Jenny") and wearing her French-inspired leather flying suit, circa 1923. *Photo 92-13721, courtesy of Smithsonian Institution/National Air and Space Museum.*

her children had an education. Bessie even managed one semester in college before moving to Chicago to work as a manicurist. It was her brother John, returned from the war in Europe, who told her of the female pilots he'd seen there and reignited her desire to rise—literally—above the cotton fields.

Bessie tried American training schools, but they wouldn't take her because she was black. Since France was the epicenter of aviation, she began studying French and applying to schools there. (Ironically, several rejected her because she was a woman.) Late in 1920, Bessie arrived in the Somme to study at L'Ecole d'Aviation des Freres Caudron; she returned to America in September 1921 with a pilot's license from the esteemed Federation Aeronautique Internationale. She went back a few months later to learn the intricate techniques and aerobatic skills that would let her join the air show/barnstorming circuit, where the money was.[4] Her daring soon led to her being called "Queen Bess" and "Brave Bessie."

She performed in a military-style costume that was heavy on the leather but very dashing. Bessie traversed the country, refusing to appear at venues where blacks were slighted or banned, and hoped to earn enough to open a training school for black pilots. She also lectured at both adult and school venues, showing films of her aerial exploits.

Bessie could afford only used and U.S. Army surplus planes, which were not always in the best condition. In 1923, she had her first crash and took a year off to recuperate. Her luck ran out on April 30, 1926, at a practice run for a Jacksonville, Florida air show in which she would jump from the plane.

With her mechanic flying up front, Bessie took the back seat so she could lean out to see the field. But doing so required that she unhook her safety belt. When a wrench fell loose and jammed the controls at 3,500 feet up, she managed at first to stay in the plane. But when it flipped over, she plummeted to the ground.

"Brave Bessie" was buried in Chicago. To this day, black pilots fly over her grave every April 30 and drop flowers to honor her. Soon after she died, Bessie Coleman Aero Groups began organizing and sponsored the first black air show in 1931. The first black training school—Bessie's dream—opened in 1938; its graduates helped train the Tuskegee Airmen. Chicago has a Bessie Coleman Drive near O'Hare International Airport and a Bessie Coleman Day. In 1995, the U.S. Postal Service issued a stamp with her likeness. Actress Madeline McCray opened her one-woman show, "A Dream to Fly: The Bessie Coleman Story," while Bessie impersonators often appear at the National Air and Space Museum to tell new generations her story.

FIRST AND ONLY ALL-WOMAN FLYING SCHOOL/ ONLY ALL-WOMAN AIR BASE IN THE UNITED STATES: WOMEN'S AIRFORCE SERVICE PILOTS (WASP)/ AVENGER FIELD (1942–44)

When the United States entered World War II late in 1941, the U.S. Army Air Forces (later the U.S. Air Force) didn't have nearly enough pilots. All available pilots and trainees—men, of course—were pressed into combat service, but that placed a real hardship on civilian traffic and even on the military. Factories were building planes as fast as they could, but who would fly them to their destinations?

Enter the women.

The idea of using female pilots in the military and to ferry planes was first broached in 1939 but discounted, as women were viewed as being too frail for the job. By the fall of 1942, however, the United States military, strained by fighting a war on two fronts, saw the light. Two female units were formed to

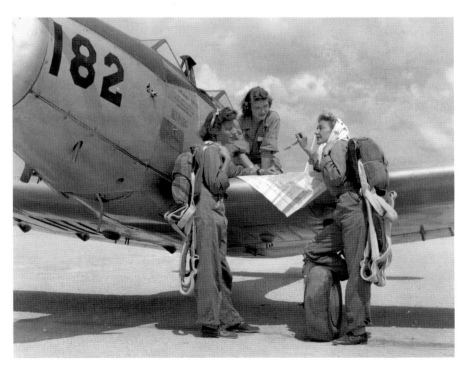

WASPs Nelle Carmody, Enid Fisher and Lana Cusack check maps prior to their flight from Avenger Field, August 1943. *Courtesy of WASP Archive, Texas Woman's University.*

free up men for combat: the Women's Auxiliary Ferrying Squadron (WAFS) in Delaware and the Women's Flying Training Detachment (WFTD) in Houston. In 1943, they merged and became the Women's Airforce Service Pilots, or WASPs.

Candidates had to be licensed civilian pilots and have a high school education. Of the 25,000 women who applied, only 1,830 were accepted and just over 1,000 graduated. While the WAFS began moving planes from one location to another, the WFTD began training in Houston but moved in February 1943 to better flying conditions in Sweetwater, west of Abilene. American and British pilots had been training at the city airport there (renamed Avenger Field), but by April, the last men had graduated, and the base was turned over to the female trainees and their military instructors.

Between February 21, 1943, and December 20, 1944, when they were disbanded, WASP graduates trained to fly every type of Army Air Forces plane. They flew sixty million miles, ferried almost thirteen thousand planes, towed targets for gunnery practice, flight-tested planes and even flew simulated bombing missions. Thirty-eight died, almost half of them from Texas.

And they did all this as civilians. Efforts to assimilate them into the Army Air Forces failed; by late 1944, the end of the war seemed near, and male pilots wanted their jobs waiting when they returned. The women were sent home to their "proper" spheres. Not until 1977 were they granted military status and pensions by Congress.

Today, you can visit Avenger Field and the National WASP World War II Museum in Sweetwater. WASP archives are housed at Texas Woman's University in Denton.

Chapter 2

ARTS AND ENTERTAINMENT

FIRST PROFESSIONAL PHOTOGRAPHER IN TEXAS: MRS. DAVIS

French artist Louis Jacques Maude Daguerre perfected a process in 1839 that imprinted an image on a small, silvered metal plate—a daguerreotype, as he modestly named it—that was so prone to damage, it had to be protected in a leather case. Cheap in comparison to having an artist paint you, these portraits quickly became the rage.

Itinerant daguerreotypists such as a Mrs. Davis, who advertised her services in Houston's *Telegraph & Texas Register* in December 1843, moved from town to town, staying a few days, weeks or even months before moving on.

Mrs. Davis's advertisement is the first record of a daguerreotypist at work in Texas, but none of her portraits are known to exist. The oldest surviving and datable Texas image is of the Alamo in 1849. Today, it is in the collection of the Dolph Briscoe Center for American History at the University of Texas–Austin.

First American Sex Symbol:
Adah Isaacs Menken (circa 1836–1868)

Her tombstone in Paris, France, is engraved with the words "Thou Knowest." If so, God is the only one who knows the real story of Adah Isaacs Menken.

Jewish and probably of mixed ethnic heritage, she was born Ada(h) Théodore in a New Orleans suburb. Beyond that, it's hard to be sure of anything else because she told so many tales about her life. Adah longed to be accepted as a literary figure and wrote and published poetry all her life, but it was her lush Marilyn Monroe–like curves that put her in the spotlight—that and her willingness to put those same curves in the spotlight.

Billed as "Miss Ada Théodore," she and her sister, "Miss Josephine," arrived in Texas in 1854 after stops in New Orleans and Havana, where they performed with local actors, sang and danced. A San Antonio critic found Ada's El Bolero dance "indeed fascinating" and added that it earned "abundant applause."[5] The sisters spent several months in Washington (-on-the-Brazos), playing to appreciative audiences. Ada often played male roles such as in "the grand nautical drama of *Black-Eyed Susan*."[6]

On other nights, Ada did readings from Shakespeare, presenting "able, true, and natural representations of the various characters…Such ability, in one so young," wrote the *Texas Ranger* critic of eighteen-year-old Ada's acting, "gives promise of future distinction and eminence in her profession."[7] But she also ruffled "certain 'pinch back' moralists" in Washington with her theatrics and skimpy costumes, enough so that she considered moving on.[8] The critic admonished her naysayers to be cautious of casting the first stone.

Over the next year or so, Ada also appeared in Austin, Galveston, Houston and Liberty. She even published poems and essays in some local newspapers where she played.

On April 3, 1856, she married Alexander Isaac Menken in Livingston, Texas (northeast of Houston). He was the Jewish son of a Cincinati dry goods merchant and a musician. How and where they met is anybody's guess. Returning to his home, she studied Judaism and wrote for *The Israelite*.

What happened next is also unclear. Did the couple divorce before she married a prizefighter in New York in 1859? Whatever the answer, Adah (as she was now known) had finally made her New York debut, and the scandal of possible bigamy kept her in the public eye.

But it was not until 1861 that the public's eye was really filled. Adah had accepted the title role in *Mazeppa, or the Wild Horse of Tartary*, based on a poem by Lord Byron. In the climax, Prince Mazeppa is strapped to the back of a

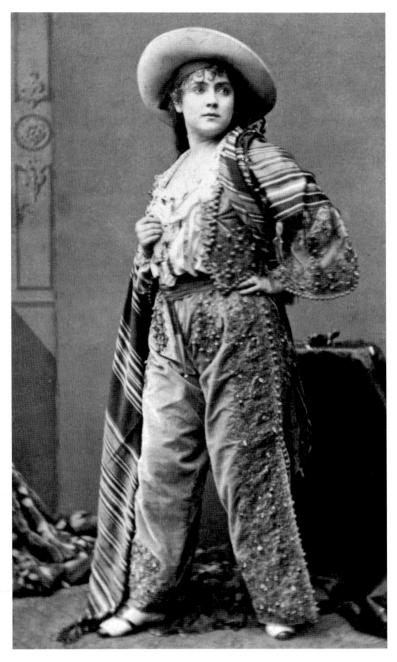

Adah Isaacs Menken, dressed for her performance in *Child of the Sun*, photographed by Napoleon Sarony in New York City, circa 1866. *Courtesy of the Harry Ransom Center, University of Texas at Austin.*

black horse charging up a mountain during a storm. The kicker was that Adah did the scene dressed in flesh-covered tights "with the small end of a dimity nothing fastened to her waist," as Samuel Clemens (aka Mark Twain) exclaimed. To audiences, she appeared nude. "The Naked Lady" had hit the big time and shocked even a nation at war.

Adah played *Mazeppa* across the country and in Europe; she was said to have been the most photographed woman in London at the time. The facts about her life are few and include at least four husbands and two children who died. But the stories are endless. A century before American media invented "hype" and "spin," Adah had the concepts down pat.

Adah Isaacs Menken made and lost several fortunes, dying in Paris, probably of complications from a stage injury. She was just thirty-two.

Largest U.S. Parade Conceived and Organized by a Women's Group: Battle of the Flowers Parade/Fiesta San Antonio (1891)

The ladies of San Antonio lay claim to this major event, which dates to 1891. It seems that Ellen Slayden, wife of a congressman, dreamed up the idea of a parade as a salute to the heroes of the Battles of the Alamo (February 23–March 6, 1836) and San Jacinto (April 21, 1836), where Texas won its independence from Mexico. And because U.S. president Benjamin Harrison was scheduled to visit "San'tonio" about that same time, the date was moved to accommodate him. But you just never know what will happen in a Texas spring, and the parade had to be postponed until several days after Harrison's rainy-day visit. People were so happy to see the sun that they joyously pitched flowers at one another as they circled Alamo Plaza in their flower-bedecked carriages—hence the name, Battle of the Flowers.

Today, the Battle is well into its second century, and its descendant, Fiesta San Antonio (1959), runs nine to ten days. It takes about fifty thousand people to stage all the events and parades. Included are the Fiesta Flambeau Parade (once the largest illuminated night parade in the country); Night in Old San Antonio, which highlights the original village adjacent to the Alamo; and the Texas Cavaliers River Parade. But the granddaddy of them all is the Battle of the Flowers Parade, still staged by the all-women Battle of the Flowers Association and the second-largest parade in the country behind

the Tournament of Roses Parade. You can recognize these hardworking, volunteer women on Parade Day because they're all wearing yellow hats and dresses.

FIRST AMERICAN WOMAN TO BE ADMITTED TO THE PARIS CONSERVATORY OF MUSIC/FIRST FEMALE PIANIST TO DEBUT AT CARNEGIE HALL/FIRST WOMAN TO PERFORM ALL THIRTY-TWO BEETHOVEN PIANO SONATAS: LUCY HICKENLOOPER (AKA OLGA SAMAROFF) (1880–1948)

She was born Lucy Jane Olga Hickenlooper in San Antonio, the daughter of a piano teacher and granddaughter of concert pianist Lucy Grunewald, both of whom recognized Lucy's talent at an early age. The family later moved to Houston and then to Galveston, where Lucy emerged as a star of the Ladies Musical Club.

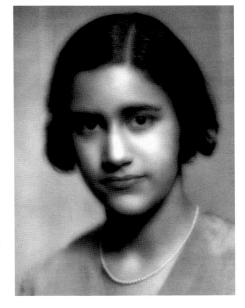

In 1894, when Lucy was fourteen, her grandmother took her to Paris to study with teachers such as Antoine Francois Marmontel, whose students included Georges Bizet and Claude Debussy. The prestigious Paris Conservatoire de Musique—"one of the most inaccessible institutes in the world"—took note of Lucy and admitted her as a "listener" to the lectures.[9] And despite her handicaps as both an American and a female, the Conservatoire admitted her as a full piano student in 1896, 1 of only 12 from 176 applicants. But anti-American bias eventually led her to leave and continue her studies with private teachers in Berlin, where she met and briefly married a Russian engineer.

In 1935, Olga Samaroff was one of twenty-five musicians chosen to work on the Federal Music Project of the Works Progress Administration. *Courtesy of Flickr/Creative Commons.*

Lucy returned to America around 1904 to become a concert pianist—a profession then dominated by males—and changed her name to the more exotic Olga Samaroff, adopted from a Russian ancestor. With borrowed money, she hired both the New York Symphony and Carnegie Hall to make her American debut and won rave reviews. In 1911, she married organist and conductor wannabe Leopold Stokowski; then more famous than he, Lucy helped launch his career. They had a daughter, Sonya, before divorcing in 1923.

By 1924, Lucy was one of the earliest musicians to record her work, thanks to her friendship with Thomas Edison. She became the only woman to perform the complete series of Beethoven's sonatas and was hired as the first American faculty member of the Julliard School of Music. After an injury forced her to give up the concert stage, she was hired as the first female music critic of the *New York Evening Post*, gave a series of popular lectures on music appreciation and taught piano students. She undertook many music projects and received a number of awards and honors.

In 2010, her life was documented in the film *Virtuoso: The Olga Samaroff Story*, based on the book by Donna S. Kline.

First Woman to Break Trapshooting Record/ First American Woman to Qualify as a National Marksman Using a Military Rifle/First Person to Coin the Word "Plink": Elizabeth Servaty "Plinky" Toepperwein (1882–1945)

Elizabeth was just a young woman working in the Winchester Repeating Arms Company in Connecticut and had never fired a gun when she met a Texas sharpshooter named Adolph Toepperwein. "Ad" was an exhibition shooter promoting Winchester Arms and had already set many records. The two married in 1903, and the young bride soon asked for shooting lessons. To the surprise of both, she was a natural, leading them to a forty-year career in exhibition shooting. She acquired her nickname when she finally succeeded in hitting a tin can, which produced a "plinking" sound. She exclaimed that she'd "plinked" it, and "Plinky" she became.

The Toepperweins' first performance together was at the 1904 Columbian Exposition in St. Louis, where Elizabeth broke 967 of 1,000 clay targets no bigger than a Roma tomato, thrown twenty-five feet into the air. Two hundred times over the course of her career, she shot 100 clay pigeons in a

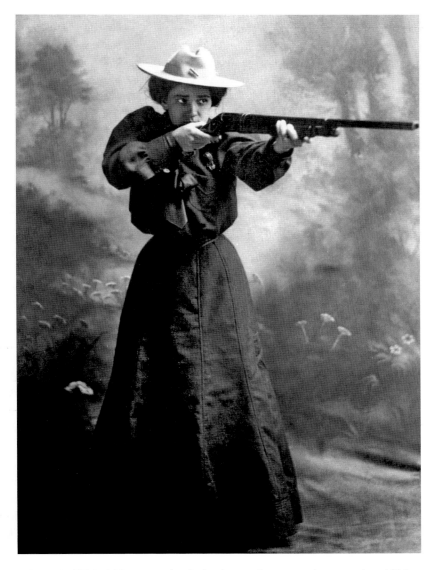

Elizabeth "Plinky" Toepperwein aiming her twelve-gauge shotgun, circa 1900. *Photo 85-810, Dora Toepperwein Morrow Collection, University of Texas at San Antonio Libraries Special Collections.*

row without a single miss, the first woman to do so. She also held a world endurance record, hitting 1,952 of 2,000 targets in five hours and twenty minutes. And the clock didn't stop while she poured ice water on her gun barrel to cool it off. Even Annie Oakley was awed by Elizabeth's skill.

Together, Ad and Plinky were crowd-pleasers. Known as "The World's Greatest Shooting Team" and "The Famous Toepperweins," they fired while standing on their heads and lying on their backs, hitting everything from marbles to eggs. In 1943, the pair visited seventy military camps on their forty-third exhibition tour. The *Milwaukee Journal* marveled that they shot cans of tomatoes "with startling effect."[10]

The couple always returned to their ranch near Boerne or home in San Antonio, where their only child died in 1940 and Plinky herself passed on five years later. Her Winchester 1890 repeating rifle is now in the Cody Firearms Museum in Wyoming, and in 1969, along with Annie Oakley, Plinky was inducted into the Trapshooting Hall of Fame…as Mrs. A.D. Toepperwein.

Founding President of the Texas Federation of Music Clubs/First Two-Term Female President of National Federation of Music Clubs: Lucile Manning Lyons (1879–1958)

Music was the passion that drove Texas native Lucile Manning Lyons through a career that lasted more than half a century.

A graduate of the Peabody College for Teachers and the University of Nashville, she arrived in Fort Worth in 1903. Pleased to find the Harmony Club already at work bringing music to the city, she joined immediately and served as its president for twenty years. One of her early projects was to gather a "Monster Chorus" of one thousand schoolchildren in a city park to sing for the Fourth of July.

Lucile led the club as it made Fort Worth a cultural center, with audiences coming from as far as four hundred miles away to attend concerts and presentations. By 1923, the Harmony Club was foremost in the nation in this respect. The greatest triumph for both the club and Lucile came in 1920, when she traveled to New York to request legendary Italian tenor Enrico Caruso to come to Fort Worth. He agreed to add "Cow Town" to what would be his final tour. Approximately eight thousand fans from across the Southwest filled the Coliseum at the Stockyards, the only place big enough to hold them. The receipts for that one night totaled $20,000—equivalent to more than $250,000 today and the largest amount Caruso ever earned for a single performance.

In 1915, Lucile helped found and served as first president of the Texas Federation of Music Clubs, uniting groups around the state. Within two

As a concert promoter, Lucile Lyons brought the New York Philharmonic, the Ballet Russe, Will Rogers and others to perform in Fort Worth. *Photo LC-B2-5487-1, Library of Congress Prints and Photographs Division.*

decades, Texas had 419 clubs, the most in the country, and its monthly publication was the only one in the Southwest devoted to music. Lucile's work attracted the attention of the National Federation board, and she subsequently became to first woman to serve two terms as president (1921–25), remaining a director until 1955.

Somehow, Lucile also found time for civic work, cofounding the Goodfellow Fund in 1921 (still in existence today) and helping the YWCA and Fort Worth Relief (later Welfare) Association.

In 1926, she became an independent concert manager, bringing a variety of stars such as German contralto Ernestine Schumann-Heink, Polish pianist and composer Paderewski, the Ballet Russe de Monte Carlo and cowboy humorist Will Rogers to venues across North Texas.

LARGEST FLORAL EVENT IN TEXAS: TEXAS ROSE FESTIVAL (1933)

Peaches used to be the big crop in the northern sections of East Texas. But bugs and repeated droughts and freezes wiped out the orchards, so growers decided to put their good, sandy soil to another "crop": roses. As early as the mid-1800s, folks there had begun experimenting with the fragrant plant; the first recorded sale was in 1879. Large-scale production on a commercial level started around the turn of the twentieth century, with the first train carload shipped out in 1917. By 1930, field-grown roses and rose bushes were a $1 million-a-year industry, especially in Smith County. That's equivalent to $13 million today.

An iconic "Yellow Rose of Texas" from the Fort Worth Botanic Garden. *Ann McLeRoy Photography.*

In 1933, the Tyler Garden Club, the chamber of commerce and local growers met to discuss ways to publicize their burgeoning business. The result was the first East Texas Rose Festival, staged that October at a cost of $1,500 and featuring rose petals tossed from an "aeroplane" over the entire parade route. (The "East" was dropped in 1936.) The modern festival, with its traditional rose show, parade and queen's coronation, along with art and car shows and concerts, attracts over 100,000 people to Tyler,

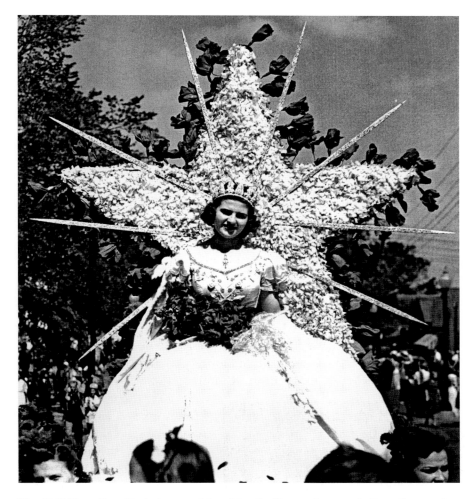

The 1940 Texas Rose Festival queen, Mary John Grelling, on her parade float. *Courtesy of Texas Rose Festival Association.*

the "Rose Capital of America," every October. The rest of the year, visitors can tour the Tyler Rose Garden—the largest municipal rose garden in the country—begun in 1938 by the Works Projects Administration and now encompassing fourteen acres and boasting five hundred varieties of roses.

The Tyler Rose Museum, opened in 1992, tells not only the story of rose cultivation in the area but also that of the festival, using photographs, memorabilia and the spectacular jeweled queen and court costumes dating back to 1935.

There's a good chance that you have roses grown or processed in the Smith County/Tyler area in your yard, as nearly three-quarters of the roses sold in this country are handled by Tyler-area rose growers.

FIRST ACTRESS TO PORTRAY ENSIGN NELLIE FORBUSH, PETER PAN AND MARIA VON TRAPP: MARY MARTIN (1913–1990)

She was the original cockeyed optimist, but her heart belonged to Daddy.

Stage, screen and television legend Mary Martin was born in Weatherford in 1913, the daughter of a lawyer and a violin teacher. As

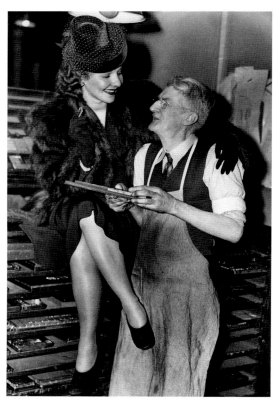

a child, and with a gift for mimicry, she began singing and dancing in public. At sixteen, she fled from a Tennessee finishing school after only a few months to marry high school sweetheart Ben Hagman. Their son Larry (1931–2012) had his own success on television in *I Dream of Jeannie* and as hardhearted, avaricious Texas oilman J.R. Ewing in *Dallas*.

Mary opened a dance studio but soon decided to make breaking into show business a full-time effort. She divorced Hagman, left Larry in Weatherford with her family and, as Mary Martin, began singing her heart out at every venue that would take her. In one nightclub, she startled customers with an operatic

Actress Mary Martin visits the newspaper office while on a visit home to Weatherford. *Courtesy of Doss Heritage and Culture Center.*

tune that segued into jazz; a producer in the audience signed her for a Broadway show. That didn't pan out, but she landed a spot in Cole Porter's *Leave It to Me*, in which she stopped the show every night belting out "My Heart Belongs to Daddy." The resulting publicity landed her a contract with Paramount Pictures, where she did ten films, co-starring with notables such as Bing Crosby. Along the way, she met and married producer Richard Halliday, with whom she had a daughter.[11]

But Martin's heart really belonged to Broadway. In 1943, she began a string of hit plays, beginning with her role as Venus in *One Touch of Venus*, which won her the New York Drama Critics Poll. Among her most memorable roles were Rodgers & Hammerstein's *South Pacific* (in which she actually washed her hair on stage one thousand times while singing "I'm Gonna Wash That Man Right out of My Hair"), the exuberant flying boy of *Peter Pan* and the young woman who would never be a nun in *The Sound of Music*. She also toured in *Annie Get Your Gun* and *Hello Dolly*, appeared with Carol Channing in *Legends* and even traveled to Vietnam to entertain troops. On television, she once more played Peter Pan (drawing sixty-five million viewers) and hosted a PBS series on aging.

In addition to her Tonys, Martin also received Kennedy Center Honors and has two stars on Hollywood's Walk of Fame.

Nor has her hometown forgotten her. Weatherford has a Mary Martin Elementary School, and a bronze statue of Mary as Peter Pan stands in front of the library. The Doss Heritage & Culture Center has recently opened a permanent exhibition on both Martin and her son, Larry Hagman.

THE ONLY PLACE YOU CAN SEE SCARLETT O'HARA'S GREEN DRAPERY DRESS: THE HARRY RANSOM HUMANITIES RESEARCH CENTER

The scene has been caricatured uncounted times, most notably by Carol Burnett. A desperate Scarlett O'Hara sees an opportunity and tells Mammy to scoot up to the attic and get her dress patterns. To which Mammy replies that Scarlett certainly won't be using "Miss Ellen's portieres" for any dress. (Actually, they were drapes, not portieres.) Of course, Scarlett wins after uttering an aggravated "Great balls of fire!" and sallies forth from Tara to wrest money from Rhett Butler, dressed in her mother's green velvet drapes and a hat adorned with the tail feathers of a rooster.

"Vivien Leigh" wearing Scarlett O'Hara's green drapery dress from *Gone with the Wind*, photographed in Madame Tussaud's Wax Museum (Los Angeles). *Photo LC-DIG-highsm-24398, Library of Congress Prints and Photographs Division.*

The legendary movie *Gone with the Wind* celebrated its seventy-fifth anniversary in 2014. Fortunately for Scarlett fans everywhere, David O. Selznick left hundreds of items from its filming to the Harry Ransom Center at the University of Texas. An exhibit at the Ransom, "The Making of *Gone*

with the Wind," marked the anniversary and featured five newly restored gowns worn by Scarlett, including the infamous green velvet drapery dress. ("I saw it in the window and I just couldn't resist it," Carol Burnett's "Starlett" declared.)

If you missed the exhibit (which closed on January 4, 2015) and just have to have some *Wind* in your life, you're in luck. Make your way to the historic river port town of Jefferson (south of Texas's own Atlanta) and Scarlett O'Hardy's Gone with the Wind Museum. Diehard fan Bobbie Hardy has one of the largest private collections of *Gone with the Wind* memorabilia, including more than one hundred American and foreign editions of Margaret Mitchell's book; movie posters from around the world; seats from Atlanta's Loew's Grand Theater, where the film premiered in 1939; many commemorative items; photos and autographs of the stars; and much more. Even Cammie King, who played Bonnie Blue Butler, has visited. So should you!

First U.S. Theater Director to Use Arena Staging: Margaret Virginia "Margo" Jones (1913–1955)

They called her the "Texas Tornado." And playwright Tennessee Williams, whom she discovered, described her as a combination of Joan of Arc, Gene Autry and nitroglycerine.

Margo Jones, born in Livingston, Texas, graduated high school at fifteen and entered the Texas State College for Women (now Texas Woman's University), where she was nicknamed "Margo" and earned a BA in speech (1932) and an MA in psychology and education (1933). She spent the next several years honing her skills in Texas and California theaters, traveling around the world to see others in action. In the fall of 1936, she was hired to direct Houston's new Community Players and struggled to find air-conditioned venues in the city's heat. Only hotel ballrooms were available, forcing her to adopt a new style of production called in-the-round, or arena, staging. In this format, the audience surrounds the stage, and actors must play to all directions, not just toward the front. Her design won her a place as the only woman in *Stage Magazine*'s 1939 top twelve directors outside New York City.

Those two concepts, arena staging and bringing theater to Americans who didn't live in New York, drove her work the remaining years of her short life. Margo traveled constantly, directing in other major cities and teaching at the University of Texas (1942–44). She directed Tennessee Williams's *You Touched Me*

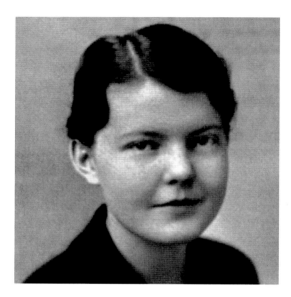

Margaret "Margo" Jones from the 1931 *Daedalian*, the yearbook of Texas State College for Women (now Texas Woman's University). *Courtesy of The Woman's Collection, Texas Woman's University, Denton, Texas.*

in several venues, bringing him to national attention. A Rockefeller Foundation grant let her pursue her goal of opening a theater in Dallas; directing Williams's *Glass Menagerie* there won her the 1945 New York Drama Critics Circle Award and made her dream a reality.

The first professional in-the-round theater in the country finally opened in the summer of 1947. Beginning as Theater '47, it changed its name every subsequent New Year's Eve—Theater '48, Theater '49, etc. Even the building was nontraditional. The Magnolia Lounge was built in Dallas's Fair Park for the 1936 Texas Centennial in an Art Deco/European Modernist style and used for promotion by Magnolia Oil (later Mobil).

Margo's theater premiered many plays we now consider classics, among them *Summer and Smoke* and *Farther Off from Heaven* (later retitled *The Dark at the Top of the Stairs*). But it was 1955's controversial *Inherit the Wind*, based on the Tennessee "monkey trial" about teaching evolution in schools, that put Margo Jones in an altogether different category as a theater pioneer. No one in New York would produce the play. But it spoke to something deep in her Texas roots. The play proved a hit and eventually went on to Broadway and Hollywood. As coauthors Jerome Lawrence and Robert E. Lee declared, "*Inherit the Wind* might still be in the dark of our files if Margo had not shown it to 199 excited Texans."[12]

Among the actors nurtured by Margo Jones were Larry Hagman (*Dallas*), Louise Latham (*Marnie*), Brenda Vaccaro (*Midnight Cowboy*) and Ray Walston (*The Sting*). She was also the first Dallas director to use black actors and to desegregate her audiences.

The Texas Tornado died suddenly in 1955 only a few months after *Inherit the Wind*'s success, accidentally poisoned by fumes from cleaning the carpet

in her apartment. She was buried in her hometown of Livingston, and her birthplace is now a state historical landmark. Though her original venue closed in 1959, there is now a Margo Jones Theater at Southern Methodist University and another at Texas Woman's University. In 1961, Jerome Lawrence and Robert E. Lee established the Margo Jones Award to honor her legacy.

First Bilingual Education Television Program in the United States: *Carrascolendas* (1970) and Aida Nydia Barrera

Today, Spanish-language stations are everywhere on television and radio, and characters such as Dora the Explorer have huge fan bases. So it's hard to remember or believe that there was a time—not so long ago—when media

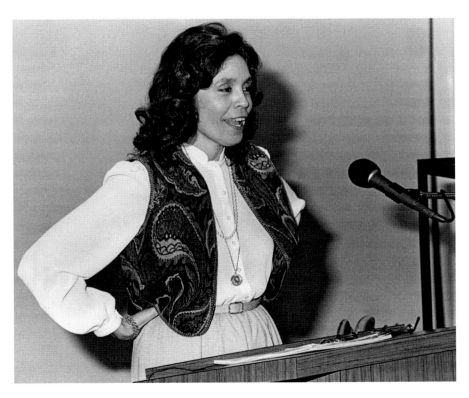

Aida Barrera speaks at the Miami-Dade (Florida) Community College in 1983. *Courtesy of State Archives of Florida.*

was largely white and English speaking, and non-Anglos were characterized as criminal or stupid. The Bilingual Education Act of 1968 and growing ethnic awareness changed that.

A journalism graduate of the University of Texas, Aida Barrera worked at KLRN (now KLRU), a PBS station in Austin, where she hosted a live children's puppet show that encouraged bilingualism and produced more than four hundred Spanish-language documentaries. Born and raised in Texas's Rio Grande Valley, Aida had grown up with a rich family and societal history that she believed would translate well to television. The first step was to convince the U.S. Office of Education.

Her mythic village of Carrascolendas was taken from the original Spanish name of Rio Grande City, where Aida was born. The half-hour episodes used a single story line with original songs and dances and were designed to help Mexican American children who felt neither Mexican nor American. *Carrascolendas* debuted in 1970 and, several years later, was picked up by PBS for national distribution. The expanded budget then allowed the show to be filmed on location and to address needs of other Latino children.

By the time funding ran out, other bilingual shows such as *Villa Alegre* were in production. PBS continued to rerun original *Carrascolendas* shows throughout the 1980s and 1990s. Today, you can easily find them online.

Aida Barrera left KRLN and went on to a distinguished career producing educational programs, filming ethnic documentaries and consulting with/serving on the faculties of many educational institutions. Her work has earned her numerous awards and honors. In 1987, she founded Telemar Communications and is president of the Southwest Center for Educational Television, both located in Austin.

Barrera wrote her 1992 doctoral thesis and a book on *Carrascolendas*, and other writers have also examined the show's impact on bilingual education in the United States.

FIRST TEXAN TO WIN NATIONAL ENDOWMENT FOR THE ARTS HERITAGE FELLOWSHIP: LYDIA MENDOZA (1916–2007)

She was known by several names: *La Alondra de la Frontera* (The Lark of the Border), *La Cancionera de las Probres* (The Songstress of the Poor) and the First Lady of Tejano Music.

Lydia Mendoza, pictured here in 1948, was known as the "Border Nightingale." *Photo 3514-A, San Antonio Light Collection, University of Texas at San Antonio Libraries Special Collections.*

Lydia Mendoza was born in Houston after her family fled north to escape the violence of the Mexican Revolution. She learned to play the guitar from her mother and grandmother, building her own instrument when she was only four. The family formed a band and toured South Texas during ethnically strained times when signs often read, "No dogs or Mexicans allowed." In 1928, when Lydia was twelve, Cuarteto Carta Blanca cut its first professional record; the family then left Texas briefly

but soon returned to San Antonio. Lydia's voice and her impassioned performance on a modified twelve-string guitar attracted a radio broadcaster who offered her a regular spot on his show. Her solo career was cemented at a 1934 record audition with *"Mal Hombre"* ("Evil Man"), a tango she learned after reading the lyrics on a bubble-gum wrapper. At eighteen, Lydia had her first hit and signature song.

She continued to tour with her family but performed as a soloist with only her guitar to accompany her—then unusual for a Mexican woman. By the time World War II broke out, she had already recorded more than two hundred songs—many of them ballads, which were her favorites—and was one of the most popular singers in the border region. She sang in a vernacular style, using the words and tunes of the working people.

War and gas rationing brought an end to touring and recording, but Lydia and the family resumed after 1945. When her mother died in 1952, effectively disbanding the family group, Lydia ventured south into Mexico and Latin America, gaining new fans. The folk music movement of the 1960s brought her an entirely new audience—white American college students—which led to the reissue of many of her recordings in the 1970s.

By the time a stroke ended her career in 1988, Lydia Mendoza had recorded fifty-plus albums, been selected by Mexico to perform at the Smithsonian Festival of American Folklife in Canada (1971), performed for President Jimmy Carter's inauguration (1977) and became the first Texan to win the National Endowment for the Arts Heritage Fellowship (1982). In 1999, she received the National Medal of Arts from President Bill Clinton. At home in Texas, Mendoza was inducted into the Texas Woman's Hall of Fame and the Tejano Music Hall of Fame. She has been one of National Public Radio's 50 Great Voices and was the inaugural issue of the U.S. Post Office's Music Icons series.

The thrilling voice of the Lark of the Border was silenced at the age of ninety-one.

First *American Idol* Winner: Kelly Clarkson (1982–)

Kelly Clarkson can trace her success to the junior high school teacher who heard her singing in the halls and encouraged her to join the choir. Eight years later, she was standing on the stage of *American Idol*.

Born in Fort Worth, Kelly grew up in nearby Burleson, a railroad town and bedroom community. Her parents divorced when she was young, and watching her mother's struggles influenced her later music, compelling her to tell other women they were capable of achieving anything they wanted.

After high school, Kelly attempted to break into the music industry and even moved to Los Angeles but returned home after she lost her apartment and belongings in a fire. A series of low-paying jobs followed before a friend told her she should audition for a new TV show.

American Idol was auditioning possible contestants across the country, including Dallas, where Kelly charmed the judges with her personality and strong voice. The show premiered on June 11, 2002, and twenty-year-old Kelly became the first Idol, with 58 percent of viewer votes. She has sold twenty million albums worldwide and has had at least nine top-ten songs, including "Breakaway."

Chapter 3

BUSINESS AND INDUSTRY

ONLY WOMAN PICTURED ON CONFEDERATE CURRENCY: LUCY PETWAY HOLCOMBE PICKENS (1832–1899)

Lucy Petway Holcombe was the physical embodiment of the ideal antebellum southern woman: charming, graceful, lovely and intelligent without appearing too much so. She also had grit, not necessarily an asset in her society but a trait that propelled her onto the world stage.

Lucy's family moved to Marshall, Texas, from Tennessee about 1850. Her first serious suitor died on a U.S. military expedition to Cuba, and Lucy assuaged her grief by writing a novel, *The Free Flag of Cuba* (rediscovered and reissued in 2002). In 1856, she met Francis Wilkinson Pickens of South Carolina, a man more than twice her age and with two dead wives behind him. He fell hard for Lucy, but she seems to have viewed him more as an opportunity. To win her, Pickens asked for a diplomatic post and was appointed U.S. ambassador to Russia.

As Mrs. Pickens, Lucy quickly became the belle of the Court of the Tsars, so much so that her only child was born in the Imperial Palace in 1859 and bore a Russian nickname: *Douschka*, or "Little Darling." The royals lavished Lucy with jewels and art, which she took home to South Carolina in 1860. There, her husband was elected governor and proceeded to start the Civil War by ordering shots fired on U.S. troops at Fort Moultrie.

Lucy Holcombe Pickens and her daughter "Douschka,"
photographed in Petrograd (St. Petersburg), Russia, in 1859.
Courtesy of the University of South Carolina–Aiken.

Lucy quickly began selling her Russian gifts to help finance a Confederate legion, which was named for her. Christopher Memminger, the Confederacy's treasurer, admired her so much that he bumped Varina Davis—wife of President Jefferson Davis—and placed two portraits of Lucy on CSA paper currency. One appeared on the $1 bill of 1862 and a second on the $100 bill issued in 1862, 1863 and 1864.[13]

Francis Pickens died in 1869, leaving Lucy to manage his plantation, Edgewood, the house now owned by and on the property of the University of South Carolina–Aiken. She also outlived her beloved Douschka. From 1876 until her own death in 1899, Lucy Pickens served as South Carolina's regent to the Mount Vernon Ladies Association, which restored the first president's home in Virginia.

INVENTOR OF THE FIRST TYPEWRITER FOR THE BLIND: ELIZABETH "LIZZIE" STHRESHLEY TOWNSEND (UNKNOWN–1919)

Elizabeth Sthreshley came to Texas as a child. She graduated from Sam Houston Normal Institute in Huntsville (now Sam Houston State University) and immediately obtained a position in Austin's Texas Institution for the Blind.

Though she worked in the literary department, Lizzie was clearly interested in both mechanics and in making life easier for the blind students there. In 1889, she filed for a patent for a "punctograph" that she'd developed. It was a typewriter for the blind that wrote in the two most popular systems, the New York Point and Braille. Made of brass and steel and weighing five pounds, it had only three keys and a spacer and could be operated with one hand. As Lizzie wrote in her patent application, the difference between her machine and others lay "in the construction and combination of parts constituting the carriage-feeding, the spacing, and the embossing mechanism." Her patent #443,977 was granted a year and a half later.

By 1894, Lizzie was at last prepared to market her machines, having "spared no time or expense in bringing this point-writer to its present degree of perfection."[14] In 1891, some controversy surrounded the state's purchase of twelve punctographs, destined for the Institution for the Blind, for $1,000, equivalent today to more than $2,000 per machine.

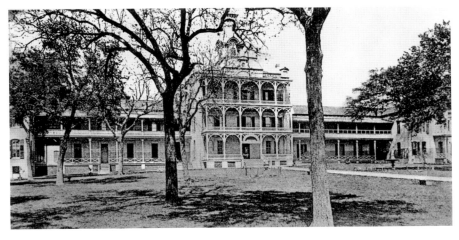

Main building at the Texas Institution for the Blind in Austin, where Elizabeth Sthreshley worked, circa 1905. *Photo 34299, courtesy of Austin History Center, Austin Public Library.*

In 1892, Lizzie also patented (#471,653) an improved slate that allowed the blind to read and write with lettered pegs.

After marrying Austin photographer George Townsend in 1894, Lizzie left her position at the Institution for the Blind. She later worked at a sanitarium in Marlin, where she died in 1919.

Most Elegant Department Store in Texas: Carrie Marcus Neiman (1883–1953)

Everyone today knows of Neiman Marcus and its influence on fashion and style. But probably few realize that NM owes that reputation to a tall, slender woman dressed in black and wearing pearls, who always insisted on the best.

Carrie Marcus was born in Kentucky, the youngest child of Jewish German immigrants. In 1893, the family moved to Hillsboro (south of Fort Worth), where cotton was king and no one had yet heard of oil. Carrie later followed

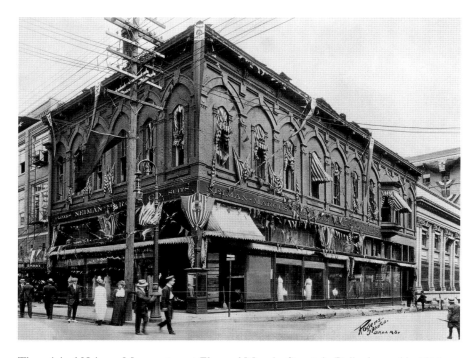

The original Neiman Marcus store at Elm and Murphy Streets in Dallas burned in 1913. *Courtesy of the Texas/Dallas History and Archives Division, Dallas Public Library.*

her brother Herbert to Dallas and sold blouses at A. Harris & Co., a rival to Sanger's, where Herbert worked. She soon became one of its top saleswomen and, in 1905, married Cleveland salesman/promoter Al Neiman.

Al persuaded Carrie and Herbert to join him in a business venture in Atlanta, Georgia, that proved so successful they returned to Dallas two years later with $25,000 and dreams of building a world-class department store. Neiman Marcus opened at the corner of Elm and Murphy Streets on September 10, 1907.

Twenty-three-year-old Carrie's style, intuitive understanding of changing fashion trends and dedication to customer service persuaded Texas socialites who had never bought anything "off the rack" that ready-made could be elegant, too. Within a month, her first inventories sold out and had to be replaced.

Both Carrie and the store suffered a divorce in 1928 when she dissolved her marriage to Al, and Herbert bought out his share of NM. She devoted the rest of her life to "The Store," becoming chair of the board when Herbert died in 1950; her nephew Stanley Marcus was then named president. Today, NM has nearly one hundred stores and outlets and owns several luxury lines.

THE FIRST WOMEN'S BANKING ASSOCIATION IN THE UNITED STATES: TEXAS WOMEN'S BANKING ASSOCIATION (1912)

The Texas Bankers Association was organized in Lampasas in 1885; in 1912, with the number of female employees rising, Lena Riddle (Steck) founded the Texas Women's Banking Association (TWBA) "to forge closer ties between women interested in banking, whether as stockholders, directors, or executives."[15] Later, wives and family members of bankers were invited to join, too. TWBA was thought to be not only the first women's banking association in this country but also the first in the world and aimed to educate women about banking laws. Members immediately undertook the promotion of two savings plans, one for schoolchildren and another for working women, who generally earned minimal wages.

The last TWBA president, Leffler Corbitt, was typical of the new businessman. A graduate of the University of Texas, Corbitt taught school and then entered banking as a clerk (circa 1896), eventually rising to the position of assistant cashier (1921) in Austin National Bank. She traveled and

Leffler Corbitt, president of the Texas Women's Banking Association, as pictured in *The Texas Magazine* in 1912. *Photo 1975/70-5434, W.D. Hornaday Collection, Texas State Archives and Library Commission.*

wrote extensively, advocated the addition of banking and general business classes for female students at UT and, in 1915, founded the Austin Business & Professional Women's Club.

America's entry into World War I in April 1917 opened even more doors for women, who rushed to fill positions at home so men could fight overseas. As Leffler Corbitt told TWBA members at the Galveston convention, "This is the first war in the history of the world in which women have participated more as a unit than as individuals...Everywhere they are entering untried fields."[16] Though she publicly denounced suffrage, Corbitt closed by stating, "The fact that she is a woman should not deter her from being ambitious."

Unfortunately, the TWBA disbanded shortly after Corbitt's speech, the victim of "a multitude of duties in connection with war work."[17] Despite that, defiantly stated the minutes, women's "importance in the banking world is now thoroughly recognized by the general public."[18]

FIRST PRESIDENT OF THE TEXAS FEDERATION OF BUSINESS & PROFESSIONAL WOMEN: DR. MINNIE LEE MAFFETT (1882–1964)

Minnie Lee Maffett spent her entire life serving others. After years teaching and serving as principal of several schools, she graduated from the University of Texas Medical Branch at Galveston in 1914 as a physician

Dr. Minnie Lee Maffett watches calf roping at the Southwestern Exposition and Fat Stock Show in 1951. *Courtesy of* Fort Worth Star-Telegram *Collection, Special Collections, University of Texas–Arlington Library.*

and surgeon. She founded and directed Southern Methodist University's health center from 1915 to 1949 and served on the staffs of several Texas hospitals over the years.

But it was through her Business & Professional Women's Club membership that Maffett made the biggest impact as founding president of the Texas Federation (1919–20) and twice president of the National Federation (1939–44). The Texas Federation established a scholarship in her name to assist

women studying to become doctors. Maffett led their fight against state and federal laws that would have barred married women from the workforce and induced the U.S. War Department to offer military commissions to female doctors serving in World War II. She also rallied the National Federation to raise more than $250,000 to build a training school and residence in Taiwan for Chinese nurses.

Known as the "Flying Doctor" for her many service trips to other countries, Maffett was returning to Texas from the dedication of the Taiwanese nurses' building named for her when she became ill and died in Honolulu, Hawaii.

First "Page Boy" Maternity Clothes: Edna, Elsie and Louise Frankfurt

In days of yore, mothers-in-waiting had few fashion choices. Most could not afford separate maternity clothes and simply let out seams or draped themselves in "Mother Hubbard" dresses or voluminous aprons. But three Dallas sisters changed that.

When budding fashion designer Elsie Frankfurt saw the tent-like outfits her pregnant sister Edna was wearing, she determined to help her out. Elsie's solutions were a panel of stretchy material that accommodated a growing abdomen and bright colors and patterns that popped. Other expectant moms saw them and asked where they could buy similar clothes. The Dallas sisters (soon to be joined by the youngest) knew they were on to a sure thing, even in the midst of the Great Depression—the beginning of Page Boy Maternity Clothes, which took off like a rocket in the post–World War II baby boom.

Soon their clothes were seen everywhere, from Hollywood to Dallas and New York. Celebrity customers included Alice Faye, Debbie Reynolds and First Lady Jackie Kennedy, all of whom enjoyed a range of clothing that even featured stylish evening dresses.

Page Boy remained a family business until the mid-1990s, when it was sold. A history of the company, *Dressing Modern Maturity* by Kay Goldman (2013), was the first winner of Texas Tech University's Lou Halsell Rodenberger Prize in Texas History and Literature.

ONLY FEMALE PUBLICITY DIRECTOR FOR A U.S. CHAMBER OF COMMERCE: ROSELLA HOROWITZ WERLIN (1904–1985)

Rosella Horowitz was the daughter of a Russian rabbi who brought his family to America and eventually settled in Texas in 1919. She was one of the state's earliest female journalists, beginning with the *San Antonio Light* in 1924. She married Joseph S. Werlin, who helped found the sociology department at the University of Houston.

Rosella began covering Houston and Galveston events for various Texas newspapers while she studied journalism and worked for the Galveston Chamber of Commerce as its publicity director in the 1930s and '40s—the only woman in the country then holding such a position. Her articles promoting the "Oleander City" covered such topics as Galveston's beloved Rabbi Henry Cohen, the seagull invasion of 1931 and Splash Day, a bathing beauty revue once known as the International Pageant of Pulchritude.

In 1982, Rosella took a stand for the rights of freelance writers when she sued *Reader's Digest* for "unjust enrichment." She had sent editors a previously published article of hers; *Reader's Digest* liked the idea but not her story and assigned the topic to a staff writer. Rosella sued on several charges, but the court found only one justifiable. It was, as the *Orlando Sentinel* noted at the time of her death, "a landmark copyright lawsuit."

After Rosella's death, her children endowed a workshop to be given annually at the state conference of what is now Press Women of Texas. The first speaker, in 1987, was feisty White House reporter Sarah McClendon of Tyler.

INVENTOR OF LIQUID PAPER®: BETTE GRAHAM (1922–1980)

Executive secretary and single mother Bette Nesmith of Dallas hated making mistakes on the new electric typewriters that came out in the early 1950s. The only way to correct errors was to erase them, which often smudged or tore the paper. An artist, Bette started mixing water-based paints in her kitchen to match the paper and used a watercolor brush at the office to cover problems. Soon every secretary in the building wanted a bottle of "Mistake Out."

Bette Nesmith Graham just wanted to help out her fellow secretaries when she developed Liquid Paper®. *Courtesy of the Texas/Dallas History and Archives Division, Dallas Public Library.*

Bette talked to a high school chemistry teacher and then got busy with her Mixmaster, bottling up what came to be called Liquid Paper®. Her son, Michael Nesmith—who was later one of The Monkees and developed the concept that became MTV—and his friends bottled it up. Bette tried to sell her ingenious idea to IBM, but it sniffed and declined, so she did what any red-blooded American inventor would do—she started her own company.

Sales were slow until an office supply magazine touted her new product; General Electric placed the first big order. Success came quickly after that. Bette built a corporate headquarters in Dallas (1968) and eventually an international one (1975). By 1977, five hundred bottles of Liquid Paper® were selling around the world every minute. But a second marriage also ended in divorce, and Bette had to go to court to fight her board of directors when they changed the product's formula, depriving her of royalties.

An ardent Christian Scientist, Bette Graham used her fortune to establish two foundations to help women, especially those in business. Liquid Paper® was sold to Gillette in 1979 and is now owned by Newell Rubbermaid.

FIRST WOMAN TO BE NAMED TEXAS REALTOR OF THE YEAR: EBBY HALLIDAY (1911–)

Ebby Halliday Acers celebrated her 103rd birthday by asking friends to donate to the renovation of a women's center for the YWCA of Metropolitan Dallas. Giving back to her community has long been one of Ebby's creeds.

Born in Arkansas, she grew up in Kansas and began her sales career at age eight, riding horseback to area farms to sell Cloverine salve. After high school, she sold hats so successfully that she was transferred to ever-bigger stores until she reached Dallas in 1938. There, she parlayed $1,000 into enough money to open her own shop. And it was hats that led her into real estate.

A friend's husband had speculated on building insulated, domed cement houses but couldn't sell them. Hats during the war years often featured strange shapes and were perched at equally strange angles on a woman's head. (Just watch any Rosalind Russell film of the period.) If Ebby could sell those crazy hats, said the husband, she could sell his concrete houses. So, in 1945, she furnished the models—then an unknown sales tactic—and proceeded to sell all fifty-two houses. Ebby Halliday was hooked.

Even as she built her real estate business into a $6.4 billion phenomenon (2013) and the twelfth-largest independent residential realty office in the country, Ebby has continued to leave people and places better than she found them. An untold number of women entered the workforce as Ebby saleswomen; she founded the Women's Council of Realtors in Dallas and served as its national president. She's passionate about cleaning up and beautifying America and has won more awards for her volunteer service than even she can count.

Chapter 4

EDUCATION

FIRST WOMAN TO TEACH PROFESSIONALLY IN TEXAS/ LARGEST BAPTIST UNIVERSITY IN THE WORLD: FRANCES JUDITH SOAMES TRASK THOMPSON (1806– 1892)/BAYLOR UNIVERSITY (1845)

Frances Trask was born in Massachusetts, educated in New York and spent several years in the wilds of the Michigan Territory before moving with her family to Texas, then part of Mexico, in 1834. This cultured beauty, who could ride and shoot as well as any man, was determined to support herself and opened the first girls' boarding school in Texas in what is now Independence (north of Brenham) on January 1, 1835.

Board was a costly two dollars per week, and tuition per quarter was either six dollars or ten dollars, depending on the classes taken. Students later recalled that Frances thought nothing of throwing her six-shooter over the horn of her saddle and riding alone as much as seventy-five miles to Houston or Austin on roads "infested" with Indians and outlaws.

By 1836, Texas was at war with Mexico to obtain its independence. Following Mexico's victory at the Alamo, Frances and her family were caught up in the horrors of the "Runaway Scrape."[19] But upon returning to Independence after a Texan victory at San Jacinto, she decided to reopen her school. The First Texas Congress granted a petition for her Independence Academy in 1837, the first school chartered by the republic. Frances also received a grant of 640 acres of land for her services as a teacher under Mexican rule.

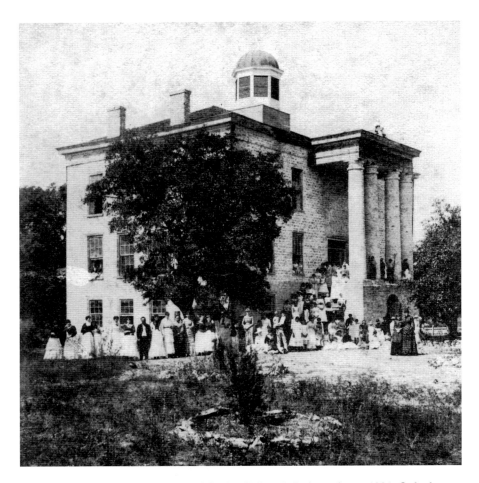

Students at the Female Department of Baylor College in Independence, 1884. Only the columns and porch survive today. *Item 9, Collection 0001/4, courtesy of Texas State Archives and Library Commission.*

Around 1841, Frances sold her school and eventually moved to Austin, where she married in 1851 and ran a hotel. Her husband lived only a few months, and she taught in Austin and several other towns before returning to Massachusetts on the eve of the Civil War.

But Frances's school endured. Her Trask Academy had become Independence Academy, which housed the first Baylor College classes in 1846.[20] In 1866, Baylor's Female Department separated from the male students; in 1886, it was renamed for Mary Hardin Baylor and moved to Belton. That same year, Baylor—the male school—left Independence for

Waco and merged with Waco University, making it the only college chartered during the Republic period to have survived without closing to the present. Baylor is also now the largest Baptist university in the world.

And it all started in Frances Trask's small schoolroom.

FIRST BILINGUAL SCHOOL IN TEXAS: RIO GRANDE FEMALE INSTITUTE (1852) AND MELINDA RANKIN (1811–1888)

In the 1840s, it took immense courage for a single woman to leave civilized New England and venture south and west on her own to bring both education to the frontier and the Bible to Mexican Catholics. But that's exactly what Melinda Rankin did.

She left New Hampshire in 1840 and spent the next decade establishing or teaching at schools in Kentucky and Mississippi before continuing on to what she feared would be the lawless wilderness of Texas. But she was pleasantly surprised by Texas's beauty and the warmth of its people. She stopped in Huntsville for several years to teach and to write her first book, *Texas in 1850*.

By 1852, she had reached Brownsville—as close to Mexico as she could get since Protestant missionaries were not welcome in that Catholic country. Moreover, many Mexicans had become stranded in Brownsville when national boundaries shifted after the Mexican-American War.

The *Galveston Weekly Journal* (1852) called Melinda Rankin "the intelligent author of that interesting volume of Texas in 1850." *Courtesy of the Presbyterian Heritage Center, Montreat, North Carolina.*

Melinda opened a school for Mexican girls, and English was one of the most popular subjects. She also supplied Bibles to Mexicans at every opportunity.

In 1854, she returned east to raise money for a larger school and found enough support among Presbyterians to build a new, spacious facility in Brownsville. Her missionary work also continued. But the Civil War drove the Unionist teacher from Texas several times. By war's end, the situation had also changed in Mexico, where Catholicism was no longer the state religion. Melinda moved to Monterrey and began her missionary work. When she retired in 1873, worn out and in poor health, she turned over to Presbyterian authorities almost twenty churches and schools that she had built in that country. Melinda wrote about her experiences in *Twenty Years Among the Mexicans: A Narrative of Missionary Labor* (1881).

FIRST DEGREED WOMAN TO TEACH COLLEGE-LEVEL CLASSES IN TEXAS: REBECCA JANE KILGORE STUART RED (1827–1886)

Rebecca Stuart was determined to get an education and teach, and she so impressed the president of Steubenville Seminary in Ohio that he let her attend without paying.[21] She graduated with a teaching degree in 1849 and, as promised, taught for several years in Kentucky to pay back her debt.

December 1852 found her moving to Gay Hill, Texas (near Brenham), with her sister and brother-in-law, a Presbyterian minister who

Rebecca Kilgore Stuart Red taught at Live Oak Female Seminary and later opened her own school in Austin. *Photo 11996, courtesy of Austin History Center, Austin Public Library.*

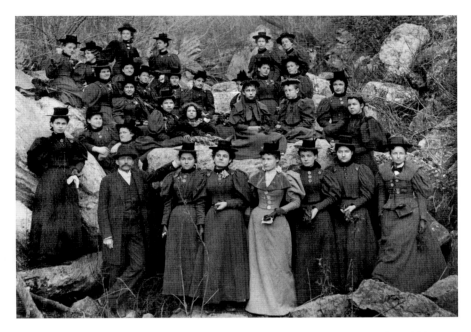

Students from Stuart Female Seminary on a riverboat excursion on Lake McDonald (now Lake Austin) in 1895. *Photo 05713, courtesy of Austin History Center, Austin Public Library.*

wanted to establish a school. At Live Oak Female Seminary, which opened a few months later, Rebecca served as principal and taught English, history, science and math. She had little thought of marrying, but the new school doctor and science teacher had other plans. Rebecca and Dr. George Clark Red married in 1854. She continued as principal and teacher even while giving birth to and raising five children.[22]

The school was largely shuttered during the Civil War and then resumed. But Rebecca and George moved to Austin in 1875, building and opening Stuart Female Seminary under her direction while the Gay Hill school closed. All the Red children taught there at some point, including Samuel—the first graduate of the University of Texas—and Lel, who became principal after her mother's death.

Rebecca Stuart Red died of cancer in 1886. Her children later donated the school property to what became the Austin Presbyterian Theological Seminary.

FIRST TEXAS TEACHERS COLLEGE FOR BLACKS: THE BARNES INSTITUTE AND SARAH BARNES

After the Civil War, the Bureau of Refugees, Freedmen and Abandoned Lands—better known as the Freedmen's Bureau—established schools for freed blacks in former Confederate and border states. Because money was short, the bureau often partnered with private and church

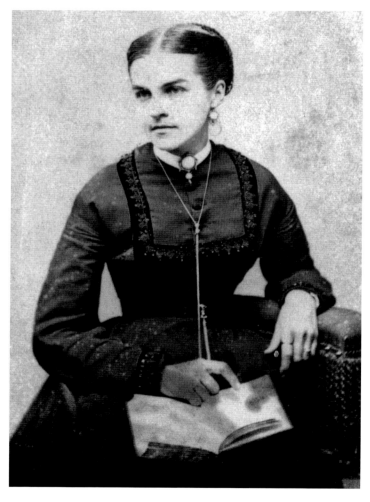

Sarah Barnes, a teacher at the Freedmen's School in Galveston and a founder of the Barnes Institute for black teachers there. *Courtesy of the Rosenberg Library, Galveston, Texas.*

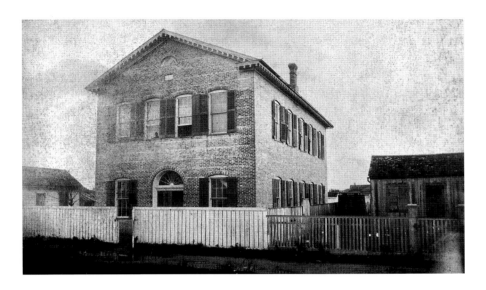

Above: The newly completed Barnes Institute building on Avenue M in Galveston, 1870. *Courtesy of the Rosenberg Library, Galveston, Texas.*

Right: Jessie Andrews was the first woman to enter and graduate from the University of Texas and was also the first female faculty member. *Photo 07908, Austin History Center, Austin Public Library.*

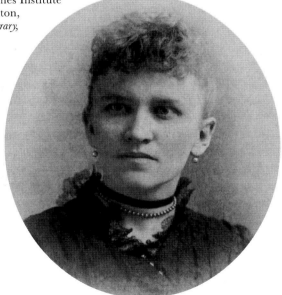

organizations to fund both schools and teachers, among them the American Missionary Association of New York (AMA).

In 1867, the AMA sent two white teachers to Galveston: Sarah Barnes from Connecticut and Sarah Skinner, also from the North, as were most of

the teachers. In ramshackle structures with "rooms of the scantiest measure and poorest quality,"[23] and with never enough supplies, the women taught sixty to a hundred or more pupils for six hours a day all week and more than a hundred at Sunday school for the princely salary of fifteen dollars a month. Teachers were hard to come by, particularly in Texas, where, in some areas, freedmen schoolteachers were attacked or even killed, pay was low and the state's remoteness from the Northeast made it difficult to reach. Galveston, on the Gulf of Mexico, was also subject to malarial epidemics such as yellow fever, which hit Northerners hard. The fall of 1867 was particularly severe; many schools could not reopen because teachers had died or gone home and refused to return.

By 1869, with Barnes and Skinner still there, the Galveston school had gained an excellent reputation as a training ground for the new generation of black teachers. Within five years, the AMA reported that "many of the old pupils of this school are now teaching in different parts of Texas."[24]

And construction was finally underway for a new facility. The AMA donated money for the property, as did city freedmen. But it was Sarah Barnes who raised $350—equivalent to more than $7,000 today—while home on vacation; in gratitude for that and her years of work, the new structure was named Barnes Institute in her honor.

Not long afterward, Sarah left Galveston, and her subsequent career is unknown. The Barnes Institute soon became a private school and then part of the city's public system.

FIRST KNOWN FEMALE STUDENTS AT TEXAS A&M/FIRST FEMALE STUDENT TO RECEIVE DEGREE FROM TEXAS A&M: THE HUTSON SISTERS/MARY E. CRAWFORD

Texas A&M University, opened in 1876, is the state's oldest public college and was originally "intended for all," but women were not officially admitted until 1963.[25] And that was only in graduate and veterinary programs. Which is not to say there weren't women around.

"Campus girls"—daughters and other family members of faculty—could attend lectures. The first known "campus girl" was Ethel Hutson (1872–1957) in 1893, who attended other colleges, including Sophie Newcomb, before her father came to A&M to teach. Ethel eventually returned to

Twins Sophie and Mary Hutson wear their Texas A&M cadet jackets, circa 1900. *Courtesy of Cushing Memorial Library and Archives, Texas A&M University.*

New Orleans and became a writer and artist of some renown. Her work with what is now the New Orleans Museum of Art helped make the city an art center. Ethel's early passion was suffrage; her papers are at Tulane University.

Ethel's younger sisters, twins Sophie (1884–1984) and Mary (1884–1982), completed all the course requirements for civil engineering in 1903 at A&M but were denied degrees. Sophie married, as did Mary, who became an

engineer in New Orleans and helped design the city's early levee system. In 2002, Texas A&M honored the twins with posthumous degrees.

The first woman to receive a degree (in English) was Mary Evelyn Crawford in 1925; her brother was head of the engineering department. But she was not allowed to attend the graduation ceremony and quietly went to the home of the registrar's secretary later to get her diploma. Texas A&M had continued the practice of faculty relatives attending lectures and even instituted summer sessions that included women, but Mary Crawford's degree so horrified some of the board of directors that they resolved never to admit women, even faculty relatives.

Today, almost half of the university's undergraduate class is female.

FIRST PUBLIC KINDERGARTEN IN TEXAS: OLGA KOHLBERG (1864–1935)

It's probably safe to say that El Paso would not be the city it is without the efforts of Olga Kohlberg. From the green hills of Germany's Rhine Valley, she came in 1884 to the city on the Rio Grande as a twenty-year-old bride, bringing with her the ideals of her native culture and education.

Olga threw herself into learning both English and Spanish so she could become involved in her new home. Seminary educated, she was well acquainted with a concept only beginning to take hold in this country: *kindergarten*. Literally a "garden of children," kindergarten was a German concept that emphasized outdoor play, self-directed activity and games and songs to release a child's creativity. Olga founded the Child Culture Club, basically a mothers' study club, in 1892, and the group hired a teacher from St. Louis and started a private kindergarten. By the following year, Olga and the other ladies had convinced the El Paso School Board that this was a good program for all the city's children. And they sweetened the pot by donating their equipment and materials—even the teacher's salary for a year.

Olga Kohlberg's philanthropy did not stop there. Over the decades, she founded or helped to establish a hospital, a public library, the El Paso Woman's Club, a city parks system, a Jewish community and temple and a baby sanitarium in the nearby cool heights of Cloudcroft, New Mexico. She was the personification of the progressive women who helped build modern Texas.

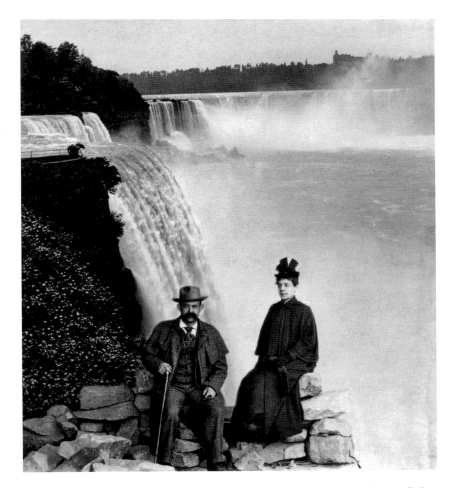

Ernst and Olga Kohlberg had a studio photograph made while visiting Niagara Falls, circa 1892. *Courtesy of the El Paso Public Library, Southwest Collection.*

OLDEST COLLECTION IN THE UNITED STATES DEVOTED TO WOMEN'S HISTORY/LARGEST AMERICAN UNIVERSITY PRIMARILY FOR WOMEN: TEXAS WOMAN'S UNIVERSITY (1932)

Since 1889, the idea of a public college for Texas women had been discussed. But not until the various women's groups throughout the state entered the fray did progress happen in 1901 with legislation establishing

a Girls' Industrial College. Texas A&M almost had it, but the school was finally located in Denton.

In 1932, in the midst of the Great Depression, President Louis H. Hubbard decided that the school's library should concentrate on collecting biographies of women who were appropriate role models for students. More than eighty years later, the result is the largest southern depository of research materials on women and one of only four such collections in the country.

The Cookbook Collection is one of the best in the nation, while the Texas Federation of Woman's Clubs records date to 1897 and those of the American Association of University Women/Texas to 1926. The archive of the Women's Air Service Pilots (see entry) is located here, as is that of the Dallas Women's Museum. In 1940, Dr. Marian Day Mullins and the Daughters of the American Revolution/Texas began assembling gowns of the state's First Ladies. (The collection is now displayed in another building.) And in 1979, the legislature designated the Woman's Collection and Texas Woman's University as the official repository of Texas women's history.

Today, with fifteen thousand students, TWU is the largest American university primarily for women.

FIRST MAJOR TEXAS CITY TO HAVE FEMALE SCHOOL TRUSTEES: DALLAS (1908)

Today it seems natural that women, who birth and raise children, should help guide their education by serving on school boards. But in 1908, even though mothers were instrumental in teaching their children, such was not the case. The Progressive Era—the first several decades of the twentieth century—was about to change that.

In Dallas, Adella Kelsey Turner (1856–1938) was well launched on her career as a Texas clubwoman. Founder or president of one organization and committee after another, Adella vigorously pursued the progressive goals of the state's woman's clubs: sanitation, public health, child protection and care, an equitable justice system and education. She was so well-known and respected in Dallas that one male incumbent school board member withdrew from the 1908 race and endorsed her.

Adella's running mate was Ella Isabella Tucker, who was active in organizing mothers' study clubs (forerunners of the PTA) and would become known for her advocacy of fire safety in schools. For their campaign

manager, the women astutely selected *Dallas Morning News* woman's editor Isadore Callaway (aka Pauline Periwinkle), who wrote several editorials on their behalf, while the city's women's groups campaigned for them. The ladies won their seats, Turner handily and Tucker barely.

But remember: women did not have the vote in 1908. Dallas's first female school board members were elected by men.

ORIGIN OF THE PARENT-TEACHER ASSOCIATION IN TEXAS: ELLA CARUTHERS PORTER (1862–1939)

Ella Caruthers married when she was only fifteen and became a mother less than a year later. Her subsequent interest in education and childcare, she later said, resulted from being totally unprepared for marriage and parenthood. Women needed to be educated for both, she believed.

With two daughters—and leaving her husband behind forever—she attended school in Nashville and the University of Chicago before returning to Hillsboro, Texas, in the early 1890s. Ella belonged to the Woman's Christian Temperance Union (WCTU), which, years earlier, had organized a Department of Mothers' Meetings, an extension of its theme to protect the home. The meetings allowed women to discuss topics of interest and were one of the forerunners, outside WCTU, of mothers' study clubs. Both, in turn, led to the eventual formation of the Texas Congress of Mothers, which became the Parent-Teacher Association.

In 1892, Ella C. Porter organized a WCTU department in Hillsboro, the first in Texas

Ella Caruthers Porter, founder of the Texas Congress of Mothers. *Courtesy of Fort Worth Public Library, Local History and Genealogy Division.*

and one of the first in the nation. She went on in 1909 to found and be elected first president of the Texas Congress of Mothers and spent the rest of her life working for mother-children organizations on both the state and national levels.

FIRST KNOWN INTERRACIAL COLLEGE DEBATE IN THE UNITED STATES: WILEY COLLEGE (1873) AND HENRIETTA PAULINE BELL WELLS (1912–2008)

She had no thought of anything more than securing a good education, and certainly not of participating in several of the most important U.S. collegiate events of the 1930s.

The daughter of a single mother, Henrietta Bell graduated at the top of her class from Houston's Phyllis Wheatley High School for black students in 1929. A small scholarship meant she could attend Wiley College, a Methodist school established in Marshall in 1873 to educate freed blacks. But Henrietta also had to work several jobs—including cleaning college dorms—to afford school, so she wasn't initially open to an invitation from poet, teacher and debate team coach Melvin Tolson.

Tolson and his debaters had already found success against other black colleges, but, in 1930, he decided to go big and scheduled a debate with the University of Michigan's Law School—a white college. And Henrietta would be the only woman and only freshman on the Wiley team.

Denzel Washington's 2007 film *The Great Debaters* told the story of Tolson's daring. Wiley won the match, although technically it didn't count since the two schools belonged to different leagues. The mighty school from Marshall continued debating white colleges and even defeated the national champion University of Southern California in 1935. Wiley also debated Fort Worth's Texas Christian University at TCU, making that the first interracial collegiate debate in the South.

But they did so without Henrietta, who couldn't afford to give more than one year to it. She graduated, married and made a career as a social worker in several states before returning to Houston. And when Denzel Washington asked, she was happy to advise on the film, even recommending he play the role of Melvin Tolson, which he did.

When she died at the age of ninety-six, Henrietta Bell Wells was the last survivor of "The Great Debaters."

FIRST TEJANA PRESIDENT OF THE TEXAS FOLKLORE SOCIETY/FIRST BILINGUAL ELEMENTARY SCHOOL PROGRAM IN TEXAS: JOVITA GUERRA GONZALEZ DE MIRELES (1904–1983)

Like Aida Barrera (see entry), Jovita Gonzalez was born in the Rio Grande Valley and never really left it, despite her moves around Texas. Descended from five generations of Mexicans and Tejanos, she spent her life uncovering the Valley's stories, mysteries and history.

Educated in both San Antonio and Austin, she studied with the now legendary Eugene C. Barker and was taken under the wing of the equally

Jovita Gonzales de Mireles with some of her pupils at St. Mary's Academy in San Antonio, 1934. *Photo LC-DIG-ds-04385, Library of Congress Prints and Photographs Division.*

legendary J. Frank Dobie, who wrote about the Texas Brush Country. They both urged Jovita to collect the Mexican American folklore of the Valley before it was gone. She succeeded so well that, in 1930, with a fresh master's degree from the University of Texas in her hand and a position teaching at St. Mary's Hall in San Antonio, she was the first Tejana elected president (1930–32) of the Texas Folklore Society, today the oldest such state organization in the country.

In 1935, Jovita married teacher E.E. Mireles. In the 1940s, the couple organized a Spanish program in the lower schools of Corpus Christi, writing texts and source books to support it—the first one in Texas public schools. The materials were later used in other bilingual school courses in the Southwest. Jovita taught Spanish and history until her retirement and continued to write folklore, as well as several novels.

First Black Woman to Serve as President of a Texas College:
Mary Elizabeth Branch (1881–1944)

The child of former slaves, she rose to become one of only a few black female college presidents in this country and the first one in Texas.

Born and educated in Virginia, Branch earned her first two degrees from the University of Chicago and taught for two decades at Virginia State College. She was serving as dean of women at Vashon High School in St. Louis, then the largest school for black girls in the United States, when she was approached by the American Missionary Society (AMS) of the Congregational Church.

In 1881, the AMS had opened Tillotson College in Austin to serve Texas's black students. Like many other such schools of the period, it

Mary E. Branch established a unique four-year home economics course at Huston-Tillotson College. *Courtesy of Huston-Tillotson College.*

offered classes from primary through college. But by 1930, Tillotson had become a junior college for women only. The resulting drop in enrollment nearly closed the school. Would Miss Branch, asked the AMS, be interested in the challenge of restoring this school?

Her first glance at the decaying buildings, scraggly grounds and pitifully small library must have horrified her. But Mary Branch saw potential. She enticed new students with scholarships, got down on her knees and pulled weeds, readmitted men, closed the secondary school, doubled the faculty and restored buildings and built new ones. By 1943, Tillotson was once more an accredited college. Mary also paved the way for cooperative classes with Samuel Huston College, and the two merged in 1952 to form today's Huston-Tillotson College.

Nor was the college her only interest. She worked for a number of civil rights causes and, in 1944, the year of her sudden death, helped establish the United Negro College Fund.

FIRST STUDENT IN THE WORLD TO EARN A PHD WITH A CD-ROM DISSERTATION: LESLIE HOPE JARMON (1952–2009)

Born and raised in Corpus Christi, Leslie Hope Jarmon always looked to the future and for ways to help others through shared knowledge. The Peace Corps (1982–87) was just an early step along a path that eventually led her to a virtual world.

After earning her BA at the University of Texas and MA from Corpus Christi State University, Leslie immediately began work on her PhD back at UT. Her thesis on "Embodied Interaction" was submitted to the faculty on a CD-ROM at a time when anybody outside the computer and video game worlds was still using floppy disks.

Leslie introduced UT to the 3D virtual world of "Second Life" in 2006 and cofounded Educators Corp. Her prowess in using "virtuality" in everyday life to teach and share knowledge made her a principal figure in tying all UT campuses and facilities together through Second Life.

Gov. Ann Richards holds the first Texas Lotto ticket sold at Polk's Feed Store in Oak Hill, 1992. The Lotto benefits Texas schools. *Photo 1992-96, Texas State Library and Archives Commission.*

Opposite, top: Charlie Mary Noble (left) and Lulu Parker (right) were among the founders of the Fort Worth Children's Museum. *Courtesy of* Fort Worth Star-Telegram *Collection, Special Collections, University of Texas–Arlington Library.*

Opposite, bottom: The future president of Texas Woman's University, Mary Blagg Huey, sits front-row center with members of the English Club, 1941–42. *Courtesy of The Woman's Collection, Texas Woman's University, Denton, Texas.*

Chapter 5

FOOD AND DRINK

LARGEST GROCERY STORE CHAIN IN TEXAS: FLORENCE CLEMENTINE THORNTON BUTT (1864–1954)

Today, it's one of America's twelve largest privately held companies. But H-E-B started in a small room in Kerrville, a desperate effort by one woman to feed her family.

Florence Thornton was born in Mississippi and graduated with high honors from college, the only woman in her class. She taught school for several years before marrying twice-widowed pharmacist Charles C. Butt. When he contracted tuberculosis around 1900, the family looked for a drier climate and moved in 1905 to Kerrville, which would become famous for its hospital that treated that disease. But with three young sons, and Charles unable to work, Florence found that she had to support her family. And she had only sixty dollars to start a business.

She rented a small building on Main Street and installed her grocery store on the bottom floor and her family on the top. While cleaning up, she found a Bible amid the trash. A deeply religious woman, Florence fell to her knees and knew the Lord would help her. She went door to door, taking orders for groceries from "Mr. C.C. Butt Staple and Fancy Groceries"; her sons delivered them in an outgrown baby buggy or wagon. Leftovers fed the family first and then anyone else who needed help. Florence frequently delivered baskets to homeless families living under the bridge over the Guadalupe River.

Youngest son Howard E. Butt returned home from World War I to help take over the business, though Florence did not retire until 1935. It was Howard who moved the store from a credit system to cash-and-carry, a new concept then. And it was he who built his mother's tiny business into the megalith that it is today.

But it's Florence's religious convictions and philanthropy that still drive many facets of H-E-B. Howard and his wife, Mary, established the H.E. Butt Foundation in 1933 to continue the generosity she'd taught the family. And because Charles Butt and two of his sons had suffered from tuberculosis, conquering that disease has been one of its focuses. H-E-B's Food Assistance Program donates to many Texas food banks, and the company has routinely donated 5 percent of pre-tax earnings to charities in both Texas and Mexico for decades.

Largest Labor Walkout in Texas History: San Antonio Pecan Shellers (1938) and Emma Tenayuca (1916–1999)

La Pasionaria (The Passionate One) literally grew up on politics. The eldest of eleven children, young Emma Tenayuca spent hours in San Antonio's Plaza del Zacate, listening to the orators addressing the many problems of the city's Mexicans and Tejanos. At sixteen, she joined her first strike, walking with female cigar makers and experiencing her first arrest.

In 1936, Emma joined the Communist Party, which supported Franklin D. Roosevelt's attempts to drag the country out of the Great Depression with the New Deal. (Many Texans considered his programs communist.) Within a year, she was executive secretary of many San Antonio chapters of the Workers Alliance of America, which aimed to help the countless unemployed. So charismatic was she that, when the city's pecan shellers went on strike, they called on Emma to lead them.[26]

San Antonio was then the major pecan-producing area in the country, but workers earned only a few dollars a week to shell pecans by hand and endured ghastly working conditions.[27] Crowded into more than 125 ramshackle plants, shellers—mostly Mexican American women—worked long hours breathing fine pecan dust (a source of tuberculosis). When their pitiful wages were halved in 1938, twelve thousand shellers walked off the job with Emma Tenayuca leading them and sharing the arrests and beatings.

San Antonio pecan shellers gather for a lunch break, 1939. *Photo LC-USF33-032701-D, Library of Congress Prints and Photographs Division.*

But her Communist connections now diluted her effectiveness; she was replaced despite the national attention given her.

In 1939, Emma was scheduled to speak on behalf of the Communist Party, but a mob attacked the auditorium, and she barely escaped. To date, this is still San Antonio's largest riot, and it cost Mayor Maury Maverick his position. Emma was driven from the city by death threats and her subsequent inability to find a job. She fled to Houston and then to California, her life as a labor organizer now behind her. She left the Communist Party, entered college to get her degrees and taught reading to migrant workers. Emma returned to San Antonio in 1968 and retired in 1982. By then, she had become an icon to a generation of younger activists.

FIRST HOT ROLL MIX/FIRST COLLEGE COMMERCIAL FOODS AND TECHNOLOGY DEPARTMENT IN THE NATION: LUCILLE BISHOP SMITH (1892–1985)

Today, TV screens are filled with anyone who wants to call himself a "chef." Lucille Bishop Smith, however, was not just a professional chef;

In 1975, Lucille B. Smith baked Christmas fruitcakes for every Tarrant County soldier in Vietnam, one of many gifts to her community. *Courtesy of* Fort Worth Star-Telegram *Collection, Special Collections, University of Texas–Arlington Library.*

she was a black female chef from the segregated South who changed America's food industry.

Born in Crockett, Lucille graduated from what is now Huston-Tillotson College. She married barbecue king U.S. Smith, and they moved to Fort Worth, where she sewed and catered. Apparently, she did both very well; in 1927, Lucille was named teacher/coordinator of the city's vocational education program, which trained young blacks for domestic service. That, in turn, took her to what is now Prairie View A&M, Texas's oldest state-supported black college, where she again focused on domestic training. She would return to PVAMU fifteen years later (1952) to establish America's first Commercial Foods and Technology Department.

In between the PVAMU ventures, Lucille stayed busy, releasing her first cookbook in card file format, consulting for Fort Worth flour company Bewley Mills and overseeing the kitchen at Kerrville's exclusive Camp Waldemar for girls. And, oh yes, she invented the hot roll mix, which makes "brown 'n serve" everything possible. Thank you!

These were not the end of Lucille's accomplishments, however. She revised her first cookbook and wrote another, baked Christmas fruitcakes for all Tarrant County soldiers in Vietnam (1965), served on the Governor's

Commission on the Status of Women (1969) and—at the age of eighty-two—founded Lucille B. Smith's Fine Foods.

And let us not forget one of her most famous recipes, the Chili Biscuit, a yeast roll with a depression in the top to hold chili and cheese. Glory be.[28]

CREATOR OF TEXAS CAVIAR/FIRST WOMAN TO WIN THE GOLDEN PLATE AWARD: HELEN CORBITT (1906–1978)

Ah, Texas Caviar—the staple of many a New Year's buffet.

And what, foreigners might ask, is Texas Caviar? Well, you start with black-eyed peas for good luck. Then you add a little garlic—just a hint, don't overpower the peas—and some diced white onion and then lightly bathe it all in vinegar and oil. Neiman Marcus used to sell thousands of cans of the stuff.

And who invented this Texas delicacy? We hate to say it, but she was a Yankee.

Helen Corbitt was born in New York State and graduated from Skidmore College with a degree in home economics. A desire to train as a doctor was sidelined by the Depression, and Helen spent several years as a hospital dietician before yielding to the lure of the University of Texas, where she taught cooking and restaurant management. (One project was to create a convention center dinner with only Texas products. *Et voila*, Texas Caviar was born.) She bounced back and forth between Houston and Austin before Stanley Marcus finally snared her for Neiman Marcus's legendary Zodiac Room in Dallas (1955), where she shocked Texans with her emphasis on fresh fruits and veggies.

At the Zodiac, Helen created some of her most beloved dishes: chicken salad with grapes and toasted almonds, which was unheard of (remember, it was the '50s); poppy seed dressing, which she swears she only borrowed and improved but meant by heaven to adorn Texas citrus; chicken tortilla soup; and her famous flowerpots—small baked Alaskas presented in clay pots and adorned with flowers.

The first of her five cookbooks was published in 1957, the last one posthumously; original copies are now collectors' items. Among her most cherished awards was the 1961 Golden Plate (Institutional Food Service Manufacturers Association); she was the first woman to be so honored.

Helen Corbitt's classic "Texas Caviar." Stanley Marcus called her the "Balenciaga of Food" for her harmonious presentations. *Ann McLeRoy Photography*.

Helen also won the highest award—the Golden Escoffier Plaque—from the world's oldest gourmet society, Confrerie de La Chaines des Rotisseurs, founded in 1248.

Many times Helen Corbitt thought of leaving Texas. We're grateful she didn't.

Chapter 6

GOVERNMENT

FIRST WOMAN TO PRACTICE LAW IN TEXAS/FIRST TEXAS FIRST LADY: FRANCES COX HENDERSON (1820–1897)

Forget TV's Lynda Carter. Frances Cox Henderson was the true "Super Woman" of this or any other age. Spoke twenty-two languages. Accomplished musician. Daring horseback rider and swimmer. Philanthropist. Built churches. Translator/writer. Practiced law. And bore five but buried three children.

Born in Philadelphia, Frances showed exceptional mental abilities at an early age, so her father took her and her sister to Europe to study. She read music at age eight and worked mathematical problems in her head. Her intellect was so finely developed that it was said that "if she had been dropped down in almost any obscure corner of Europe, she would not have found herself embarrassed in addressing people...She exemplified the highest type of American literary women."[29]

And at nineteen, this prodigy lost her heart to the "brilliant but frail" James Pinckney Henderson, the envoy extraordinary from the young Republic of Texas to England and France.[30] They married in London in 1839 and returned to Texas to make their home in San Augustine, where James opened a law office. Here was a new field for Frances, and she soon became proficient enough to carry on the practice when he was away.

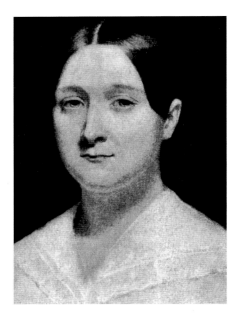

Frances Cox Henderson, as pictured in Pearl Cashell Jackson's *Texas Governors' Wives. Courtesy of Texas State Library and Archives Commission.*

After Texas became a state in 1845, he was elected governor, but the first First Lady refused to follow him tamely to Austin. He was often away, and she was busy in San Augustine with church, law, women's suffrage and family.

In 1856, after the family moved to Marshall, James was appointed a U.S. senator. Frances accompanied him to Washington, D.C., where he died in 1857. What to do next was a dilemma, for she could see the coming war. Frances "was not Northern or Southern. She was cosmopolitan, a Philadelphian by birth, an European by education, and a Texan by choice."[31] Rather than take sides, she gathered her daughters and returned to Europe.[32]

Chappell Hill was the first Texas town planned and laid out by a woman, Mary Hargrove Haller. The 1840 stagecoach inn pictured here is now a hotel. *Courtesy of Texas State Library and Archives Commission.*

After the war, Frances returned to the United States and lived with her second daughter, writing about life on her son-in-law's sugar plantation. She died in East Orange, New Jersey.

FIRST TEXAS FIRST LADY TO LIVE IN THE CURRENT GOVERNOR'S MANSION: LUCADIA CHRISTIANA NILES PEASE (1813–1905)

Lucadia Niles was born in Connecticut and educated at the Hartford Female Seminary. In 1850, she married her cousin Elisha M. Pease, and they moved to Brazoria, Texas. Their three-room house was filled with furniture from home, and Lucadia, who loved flowers, tried to grow "Yankee" gardens, to the amusement of neighbors. Elisha, a lawyer, fought in the Texas Revolution and spent much time in government positions.

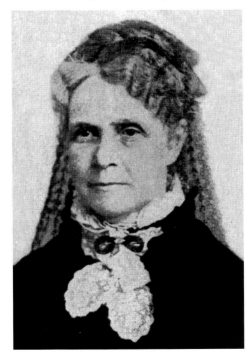

When Elisha was elected to the first of his three terms as governor in 1853, the state had no executive mansion—governors simply boarded or lived in hotels and left their families at home. But the following year, the legislature appropriated $17,000 to build and furnish a Greek Revival–style mansion. The Peases had some say in selecting the location across from what is now the Capitol. Furnishings were acquired in New York, but the budget didn't stretch to cover the whole house, so the couple added their own furniture. Given that Austin was on the frontier and still subject to Indian attacks, it was quite elegant.

For six months, Elisha lived alone in the Governor's Mansion while Lucadia and the children

Lucadia Niles Pease, as pictured in Pearl Cashell Jackson's *Texas Governors' Wives. Courtesy of Texas State Library and Archives Commission.*

went home to Connecticut for a visit. On August 23, 1856, he held an open house, with five hundred people attending. During his third term, 1867–69, Elisha refused to live in the house he'd built, as he'd sent his family back to Connecticut during the war.

Today, the Texas Governor's Mansion is the fourth oldest in the country and the oldest west of the Mississippi River. It has recently undergone an extensive restoration.

FIRST FEMALE EMPLOYEES OF THE STATE OF TEXAS: AMELIA EDITH HUDDLESTON BARR (1831–1919) AND MARTHA LUNGKWITZ BICKLER (1855–1937)

This entry is a bit complicated because it depends on how you define "employee." Amelia Barr was probably never "officially" hired but received payment for her work, while Martha Bickler is definitely the first "official" female staff member.

Born in England, Amelia married a Scotsman, Robert Barr, and they fled to America when he lost his fortune. In 1856, the family arrived in Austin, where Amelia was entranced by the beauty of the area. Austin, she wrote in her autobiography, "was built on hills, surrounded by a rampart of higher hills…and the shining waters of the Colorado [River] wound in and out among these hills…I [can still] smell the China[berry] trees and the pine. I hear the fluting of the wind, and the tinkling of guitars. I see the white-robed [gowned] girls waltzing in the moonshine down the broad sidewalk of the avenue."[33]

Robert, an accountant, immediately found work in the comptroller's office. In 1862, under the Confederacy, Amelia began working there, too. At first, she helped her husband with tax rolls. In 1863, supplies for state offices began running low, so Amelia ruled plain paper for the assessor and other departmental forms and made envelopes. Astutely, she asked to be paid in specie, not Confederate money.

At the end of the war, the family moved to Galveston, where Robert and two of their sons died. Amelia moved in 1869 to New York and began to write, publishing her first novel in 1884 at the age of fifty-three. She wrote nearly eighty novels, including *Remember the Alamo*, and is now considered a pioneer of the American historical novel.[34]

Little is known about Martha Bickler beyond the bare facts of her life. Her parents were German immigrants, her father having become a well-known

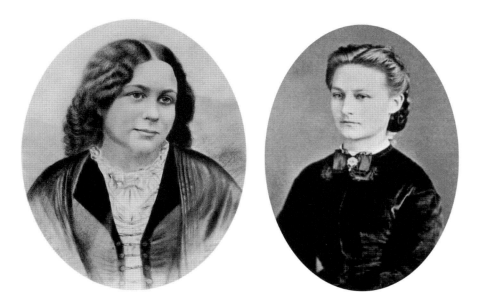

Left: This portrait of writer Amelia Huddleston Barr was made while she lived in Austin. *Photo 0001/201, Lillie Barr Collection, courtesy of Texas State Library and Archives Commission.*

Right: Martha Lungkwitz (Bickler), circa 1870, when she worked at the General Land Office in Austin. *Photo 00622, courtesy of Austin History Center, Austin Public Library.*

painter of romantic Texas Hill Country scenes. He studied photography and, in 1870, was hired by his brother-in-law, the land commissioner, as photographer for the General Land Office, which oversees the state's public lands. Martha was also employed (as a clerk) and met her husband, Jacob Bickler, when he was briefly hired as a draftsman. They married in 1874 and had nine children.

FIRST STATEWIDE MEXICAN AMERICAN CIVIL RIGHTS MEETING: JOVITA IDAR DE JUAREZ (1885–1946)

The pen might be mightier than the sword, but Jovita Idar wielded it like a sword in defense of *La Raza*, the rights of Mexicans and Mexican Americans.

She was born into a family of Laredo journalists at a time of increasing hostility and violence between Texans and Hispanics. At the outbreak of the Mexican Revolution in 1910, the Idars' newspaper, *La Cronica*, backed those

revolting against the Mexican government, which was supported by the U.S. government. Jovita first thought she could help through education, but teaching in an impoverished school proved so frustrating that she returned to the family business and wrote a weekly column condemning the discriminations—particularly against children—and war atrocities. "There are so many dead," she wrote, "that sometimes I can't remember all their names."[35]

In 1911, the Idars and *La Cronica* organized *El Congreso Mexicanista*, the first Mexican Congress, to address these issues. Two new groups were formed there, including *La Liga Femenil Mexicanista* (the League of Mexican Women), headed by Jovita, to promote public education for their children.

In 1913, she crossed into Mexico to work with *La Cruz Blanca* (some say she helped found this Hispanic Red Cross) and nursed revolutionary soldiers. On her return, she went to work for another newspaper, *El Progreso*, where her editorial protesting President Woodrow Wilson's policies brought Texas Rangers to the door. She is said to have stood in the doorway and refused them admittance, but the Rangers eventually prevailed, and Jovita returned to *La Cronica*. After her father died in 1914, she took control of the paper.[36]

In 1917, after the paper closed, Jovita married plumber and tinsmith Bartolo Juarez. For the next few years, she interested herself in more cultural activities, such as chairing the International Institute, and opened a business as a translator and typist. The couple moved to San Antonio, where Jovita was active in Democratic politics, founded a free kindergarten and continued writing.

FIRST WOMAN TO SERVE AS STATE ARCHIVIST/FIRST WOMAN TO HEAD A STATE DEPARTMENT: ELIZABETH HOWARD WEST (1873–1948)

Even in these computerized, online days, a writer of history spends much frustrating, filthy, joyous time in libraries and archives—preferably deep in their bowels, where the good stuff is. So we are grateful beyond measure to the librarians and archivists who help make our job easier. And Elizabeth Howard West was the embodiment of both professions.

A native of Mississippi, she received her first BA from the state woman's college at age nineteen, teaching in public schools there and, after a family

move in 1895, in Texas. At the University of Texas, she earned a second BA and a master's, degrees which took her to the Library of Congress from 1906 to 1911, where she catalogued the papers of President Martin Van Buren.

Her first position at the Texas State Library (1911–15) was as an archivist and allowed her to work in Mexican and Cuban archives, locating papers of relevance to Texas and the Gulf Coast. She also catalogued the papers of President of the Texas Republic Mirabeau B. Lamar. Her next position was as head of the public library in San Antonio. Elizabeth was a charter member of the Texas State Library Association and its president from 1914 to 1916.

Texas's first female state archivist, Elizabeth Howard West. *Photo 0001/122, courtesy of Texas State Library and Archives Commission.*

Austin called Elizabeth back in 1918 to become state librarian, making her the first woman to head a government agency there. During her eight-year tenure, she worked to eliminate the old, traveling library system and institute permanent locations, as well as to increase services for the blind. She helped found and was first president of the Southwestern Library Association.

The new Texas Technological College (opened in 1925) wanted the best librarian and lured Elizabeth to Lubbock, where she remained until 1942. Two exciting years of that were spent on leave in Spain as part of the Library of Congress European Historical Mission to locate documents of importance to the United States. After "retiring," she continued to work at Tech as a research assistant until 1947.

Like most historians, she was too hooked on finding "the answer" to quit.

First Female Governor of Texas/Second Female Governor in the Country: Miriam Amanda "Ma" Ferguson (1875–1961)

You have to say one thing for *le deux* Fergusons, Ma and Pa: they sure kept Austin lively.

"Pa," as James Ferguson was called, talked himself into two terms as governor. But in his second term, he tangled with the

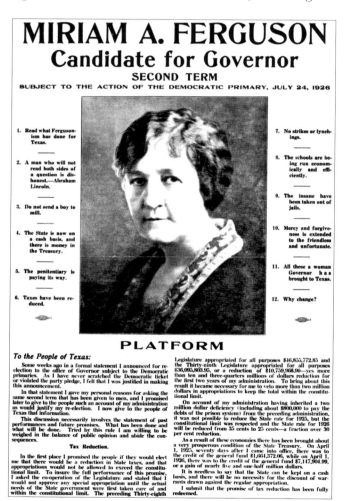

Miriam Ferguson's 1926 campaign ad boasts of the economic reforms she made in her first term as governor. *Courtesy of Texas State Library and Archives Commission.*

University of Texas board of regents, who wouldn't fire faculty members Pa didn't like. So, adhering to the old adage about he who has the gold, Ferguson vetoed UT's appropriation. By the time the dust settled on that one, Pa was explaining himself to a grand jury, and the Texas Senate removed him from office. In 1924, he had "Ma"—Miriam Amanda—campaign for governor instead. She ran on a platform of deferring to her husband and giving Texans two governors for the price of one. That slogan alone should have cost her the election, but the other candidate was endorsed by the Ku Klux Klan, and anti-Klan Texans swept her into office by an 18 percent margin.

To the north in Wyoming, a weirdly similar scenario was playing out at the same time. In this case, the governor died a month before the election, and his wife ran in his place. Nellie Ross won—with only a 10 percent margin—and was sworn in fifteen days before Ma, becoming the first female governor in the United States. Texas had to take second place.

Both Nellie and Ma lost their reelection bids; in fact, Ma was almost impeached and lost again in 1930. Two years later, she finally won her second term. Neither term was particularly noteworthy, and both were marred by charges of bribery, kickbacks and excessive pardoning of convicts. (Ma pointed out that her policy eased the financial burden of the prison system during the Depression.) At age sixty-five, she actually had the nerve to run again but lost to incumbent W. Lee "Pappy" O'Daniel of Light Crust Doughboys fame.

FIRST WOMAN TO BE NOMINATED FOR VICE PRESIDENT OF THE UNITED STATES AND VOTED ON AT A NATIONAL CONVENTION: FRANCES "SISSY" TARLTON FARENTHOLD (1926–)

Millions of words have been written about her. Trying to summarize her big-as-Texas life into a few paragraphs is a daunting task.

Corpus Christi native Frances "Sissy" Tarlton Farenthold grew up in a family of attorneys and is a graduate of the Hockaday School for Girls, Vassar College (1946) and the University of Texas Law School (1949), where she was one of only three women. She is perhaps best known for her meteoric political career in the 1960s and '70s. In quick succession, she was elected to the Texas House of Representatives (1968–72), where she was the single female member, and became leader of the "Dirty Thirty," a group of liberal

legislators determined to uncover corruption and scandal at every level of state government. She was the only representative (1969) to vote against a resolution in praise of Lyndon Johnson's Vietnam policies and, with Senator Barbara Jordan, co-sponsored the Equal Rights Amendment in Texas.

Sissy then waged a battle against elderly and conservative Dolph Briscoe for the Democratic gubernatorial nomination. She barely lost the first try (1972), the second (1974) more conclusively. Before she could recover from the last loss, certain elements in the National Democratic Party decided to make use of her recent publicity and nominated her as George McGovern's vice presidential candidate. Despite the last-minute scurry, Sissy placed second at the Democratic National Convention.

In 1976, Sissy left Texas and politics behind to become the first female president of Wells College, a women's school in New York. The first thing she did was to move the portraits of the previous twelve male presidents to the library. She then installed a Texas flag in her office that announced when she was on campus. She left Wells in strong fiscal standing in 1980 to return to Houston to again practice law.

Today, Sissy Farenthold concerns herself with human and women's rights issues around the globe.

First Black Treasurer of the United States: Azie Taylor Morton (1936–2003)

From the cotton fields of a post–Civil War freedmen's settlement to the Rose Garden of the White House, Azie Taylor Morton walked the path with dignity.

She was born in St. John Colony near Lockhart, the daughter of a deaf/mute woman and an unknown father, and was raised on her maternal grandparents' farm. Her mother's disabilities allowed her to be educated at Texas's Blind, Deaf and Orphan School in Austin since there was no high school for blacks at home. She learned politics at an early age, listening to convention broadcasts on the radio and, at age twelve, selling Lyndon B. Johnson campaign buttons to her classmates for a penny each. At Huston-Tillotson College, she earned her BS, *cum laude*, but the University of Texas's racial restrictions prevented an advanced degree.

Azie soon went to work for the AFL-CIO's Austin office (1958–61), where she campaigned for John F. Kennedy and was active in the civil

Azie Taylor Morton, later U.S. secretary of the treasury, worked in the Austin AFL-CIO office in 1960. *Courtesy of Texas AFL-CIO Collection, Special Collections, University of Texas–Arlington Library.*

rights movement, including participating in a few sit-ins. In Washington, D.C., she began a rapid rise through government labor offices and political party ranks. By 1971, she had become special assistant to the chairman of the Democratic National Committee, Robert Strauss, born just a few miles from her in Lockhart. One of her responsibilities there was to help plan the 1976 Democratic National Convention, at which fellow Texan and close friend U.S. Senator Barbara Jordan made history as the first black woman to address such a gathering.

It's not surprising, then, that in 1977, President Jimmy Carter took note of Azie and appointed her the thirty-sixth treasurer of the United States and director of the U.S. Mint, the first black person to hold that position. (She was the eighth consecutive female treasurer.) Her primary job was to oversee the U.S. Savings Bond program—and to have her signature stamped on all paper currency issued by the Mint.

Azie's later path led her many places: as a delegate to the enthronement of Pope John Paul II, an election observer on two continents, winner of the

1979 Horatio Alger Award and chair of missions to China and the Soviet Union. After decades of government service, she returned to Austin and entered private enterprise (president of an asset management company) and served on boards such as Schlotzsky's, the Austin Housing Authority and St. Edward's University.

And she even returned home, purchasing the fifty-five acres on which she was born.

FIRST AND ONLY WOMAN (THUS FAR) ELECTED AS A U.S. SENATOR FROM TEXAS: KATHRYN ANN "KAY" BAILEY HUTCHISON (1943–)

Kay Bailey, as she is known in Texas (no last name needed), has deep roots here. Her great-great-grandfather signed the Texas Declaration of Independence in 1836 and was the legal partner of Thomas J. Rusk, who, in 1846, was elected the new state's first U.S. senator. Born and raised in Galveston County, Kay Bailey bleeds burnt orange, as they say, having earned her BA (1962) and her law degree (1967) from the University of Texas. She was one of only seven women in her law class.

However, she soon discovered the very thick glass ceiling in Texas legal circles and instead talked herself into a job as a reporter for Houston's KPRC station, covering courts and politics. And that inadvertently led her into politics when an interview with Anne Armstrong, co-chair of the Republican National Committee (and, later, ambassador to the Court of St. James), brought a position as Armstrong's press secretary.

In 1972, Kay's new political knowledge and contacts made possible both her election for the first of two terms to the Texas House of Representatives (where one of her colleagues was future husband, Ray Hutchison) and a position on the National Transportation Safety Board. After a decade's hiatus, Kay was elected Texas state treasurer (1990–93) and then won a runoff election for Lloyd Bentsen's unexpired seat in the U.S. Senate, a Democratic seat since 1875. She was reelected in her own right and served ten years, retiring in 2013 as the senior female Republican senator.

As a senator, Kay focused on the military, women, family and health issues and on Texas's major defense industry. In 2001, *Ladies Home Journal* named her one of America's thirty most powerful women, and she was on John McCain's short list for vice president. A subsection of the Internal Revenue

Code for which she was lead sponsor, the "Homemaker IRA," was renamed in her honor.

UT has honored this Texas Ex with the Kay Bailey Hutchison Center for Latin American Law, which will soon be part of the Kay Bailey Hutchison Center for Energy, Law and Business for students pursuing careers in the energy industry.

The inimitable Ann Richards was Texas's first female state treasurer and its second female governor. *Courtesy of Texas State Library and Archives Commission.*

Chapter 7
LEGAL

FIRST WOMAN LEGALLY HANGED IN TEXAS: JANE ELKINS (UNKNOWN–1853)

After 160 years, we still know little about this execution.

Jane Elkins, a slave, had been hired out by her mistress to a widower, Mr. Wisdom, in Farmers Branch (near Dallas) to keep house and care for his children. In 1853, someone split Wisdom's head open with an axe while he slept but left his children unharmed.

In the previous decade, the cotton industry in the North Texas Blacklands had caused slavery to spread rapidly, and there had been regular alarms about real or feared slave uprisings. So the brutal murder of a white person immediately focused attention on any nearby slave—in this case, Jane. Her trial was conducted by Judge John H. Reagan, soon to be a U.S. congressman, and he apparently felt no need for Jane to have a lawyer. In the *State of Texas v. Jane, a Slave*, she was valued at $700, pleaded not guilty and, on May 16, 1853, was convicted of Wisdom's murder. Two weeks later, she was hanged.

For many years, even her name was lost, and another woman had the "credit" for being the first Texas woman legally hanged. Today, she is the subject of a historical drama, *The Ballad of Jane Elkins*, written by Anyika McMillan-Herod, a cofounder of Dallas's Soul Rep Theater.

FIRST LEGALLY REGULATED RED-LIGHT DISTRICT IN TEXAS: WACO (1889–1917)

Believe it or not, there was a time when the very Baptist Baylor University and legalized prostitution co-existed in the same city. Yes, it happened in Waco, the first town in Texas and the second in the country to make the world's oldest profession perfectly legitimate.

Waco in the 1870s boomed with cowhands working the Chisholm Trail, settlers moving west and railroad companies laying track. Inevitably, the ladies of the night followed, congregating near business areas and railroad depots. But in 1889, city fathers decided to restrict vice to one area and make it legal only there. And the residents couldn't leave its boundaries.

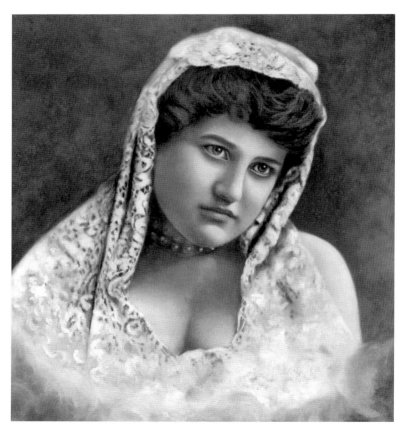

This circa 1890 portrait of famed Waco madam Mollie Adams was reputed to have cost her $500. *Courtesy of the Texas Collection, Baylor University, Waco, Texas.*

The Reservation—also called Two Street because its northern side followed Second Street—lay close to the Brazos River and the suspension bridge, a main artery into town. Required medical exams, licenses, security bonds and annual fees provided so much control over its inhabitants that police regularly warded off attempts to shut down the Reservation because it would disperse crime throughout the city.

All that changed with World War I, when the military built training camps all over Texas. Cities that wanted to have or keep a camp, with its thousands of money-spending soldiers, were ordered to clean up their vice districts—the U.S. Army didn't want its boys exposed to venereal disease.[37] The Reservation was officially closed in August 1917.

One of Waco's best-known madams was Mary Capitola "Mollie" Adams (1868–1944), born in Ohio but a resident of Waco since 1877. Mollie became a working girl at sixteen or seventeen, and by 1892, she had her own house in the Reservation, where her sister Rosa also plied her trade. Mollie did so well that, by 1910, she'd built an expensive new house with a beer room, dance hall, incandescent lights, indoor plumbing and an intercom with mother-of-pearl buttons that let her communicate with each room. She was said to have made and lost several fortunes and was still working at age fifty.[38]

But Mollie provided her own moral. She spent her last years at the McLennan County Poor Farm and died in a cheap boardinghouse.

First Woman Licensed to Practice Law in Texas: Edith W. Locke (1902)

This particular first has been claimed for several women—one of whom may have been disbarred for the early twentieth-century version of ambulance chasing—and frankly, sorting them out has not been easy. Even the State Bar of Texas archives can't make a pronouncement. That said, a license to practice law was easily come by in days of old; all you needed was a certificate of good character from your county commissioners' court and an oral exam given by three practicing attorneys.

Edith W. Locke of Chicago spent a year recuperating her health in El Paso and studied law for "recreation" while she did; she qualified for her license in 1902. "The attorneys gave the lady a most searching examination," reported the *El Paso Herald*, "ransacking all the law from the foundation of

the Roman empire through the English common law and down to the latest Texas statutes."[39]

Three days later, Edith took her license and departed for Chicago, never to return. So, technically, she's the first woman licensed as a lawyer in Texas. But since she left speedily, we'll give the nod to the following lady, who not only stayed but also used her legal knowledge to positive effect.

First Woman to Pass the Texas Bar Exam/ First Southern Woman Admitted to Practice Before the U.S. Supreme Court: Hortense Sparks Malsch Ward (1872–1944)

She wore the suffrage badge proudly, and her efforts on behalf of Texas's women changed the state.

Hortense Sparks was born and raised in the Victoria region, attended a Catholic girls' school there and later taught briefly in nearby Edna, where she married Albert Malsch. Mrs. Compton's Business School took her to Houston and a short stint as a secretary in a cigar factory. While working as a stenographer and court reporter, though, she became interested in the law and studied by correspondence course. Along the way, she divorced Malsch and married attorney William Ward.

In 1915, Hortense and William journeyed to Washington, D.C., to be admitted to practice before the U.S. Supreme Court—the first husband-and-wife team in history and the first southern woman so honored. She was given a goose feather pen to commemorate the event.

But Hortense already had a pen far more precious to her, the one used by Gov. Oscar Colquitt in 1913 to sign into law the Married Women's Property Rights Act, which she had helped draft and push through the legislature. Prior to that legislation, married women in Texas had no rights whatsoever to their property, even that which they owned before marriage or were given afterward. All was controlled by the husband, who could spend or lose it as he wished. The pamphlet Hortense wrote about this circulated widely and pulled no punches: in Texas, "a woman is legally a chattel or slave from the time she marries until her husband dies or is divorced."[40]

But the bill nearly didn't pass. The *Houston Post* reported more oratory than legislation, a "near riot" on the Senate floor and "heated debate" while "prominent club women"—who had supported the bill—gave "glances of

encouragement" or frowns to their legislators.[41] The bill is often called the Hortense Ward Act.

And she was not nearly done yet. She helped draft and championed the women's suffrage amendment, which passed in 1918 and allowed Texas women to vote in primaries—the first state in the South to do so. On June 28, the day registration opened in Houston, the hundreds of women in line stepped aside to let Hortense become the first woman to register. She also drafted the final suffrage amendment, passed in 1919 (see entry).

Hortense practiced law with her husband until his death in 1939 but never appeared in court, not wanting the legal presence of a female attorney to influence the proceedings. And in 1925, she made more history as chief justice of an all-woman Texas Supreme Court convened to hear a case in which all the male lawyers recused themselves.

That should have been an omen of a bright future, but it wasn't. Not until 1955 did Texas women earn the right to even sit on juries.

First Black Woman Admitted to the State Bar of Texas/First Black Judge in the South Since Reconstruction: Charlye Ola Farris (1929–2010)

Charlye Farris, the daughter of Texas's first black school superintendent and an elementary school teacher, graduated high school in Wichita Falls at fifteen and what is now Prairie View A&M at eighteen. She taught school for a year before deciding to pursue the law, a startling and brave choice for a black woman in post–World War II America. She enrolled at the University of Denver and then transferred to Howard University School of Law, whose alumni include Supreme Court Justice Thurgood Marshall. Charlye and her classmates were involved in preparing the historic 1954 case *Brown v. the Board of Education*, which declared segregation of public schools to be unconstitutional.

Charlye received her juris doctorate in 1953 and returned home to Wichita County on the Red River to be licensed as the state's first black female lawyer. "Civil rights" wouldn't become law for another decade, however, and Charlye encountered prejudice from juries, bathrooms and water fountains in the courthouse that were designated by race and the inability to find an office available to blacks within walking distance of the courtrooms. But in

another sense, she started off her career with a bang, being named a Wichita County judge pro tempore on July 7, 1954. That distinction made her the first black judge in the South since Reconstruction.

Charyle Farris practiced law in Wichita Falls for more than fifty years, receiving many awards for her groundbreaking career. A Texas Senate resolution in 2003 declared that she "epitomizes all that is honorable and desirable in the legal profession." In 2013, after her death, the Texas Historical Commission unveiled a historical marker about her life at the courthouse, and Midwestern State University, where she served on the board of regents from 2006 until 2010, published her biography.

First Black Female Federal Judge in Texas: Gabrielle Kirk McDonald (1942–)

Born in Minnesota, Gabrielle Kirk grew up in the Northeast. After attending Boston University and Hunter College (1963), she graduated from the Howard University School of Law at the top of her class (1966). As an NAACP Legal Defense Fund attorney, she traveled the country, assisting those involved in civil rights cases.

Texas beckoned in 1969; Gabrielle established a law firm in Houston with her then-husband and also taught at St. Mary's University School of Law in San Antonio (1970–94).[42] A decade after she moved there, Sen. Lloyd Bentsen recommended Gabrielle to President Jimmy Carter for the judgeship of the U.S. District Court for the Southern District of Texas, established in 1902 by President Teddy Roosevelt and encompassing forty-three counties along and west of the Gulf of Mexico. When she was selected, she became the first black female federal judge in Texas and only the third in the country.[43]

One of Gabrielle's most high-profile cases in Texas came in 1981, when area Vietnamese fishermen asked that special deputies be appointed to stop the Ku Klux Klan and local shrimpers from harassing and perpetrating violence against them. The KKK immediately asked Gabrielle—a woman and a black—to withdraw, but despite death threats toward her and her family, she refused. The Vietnamese won their case.

Gabrielle resigned as judge in 1988 to resume practicing law and teaching. In 1993, she was named one of the first judges of the United Nations International Criminal Tribunal at The Hague (Netherlands) to try charges of war crimes stemming from the genocide and Balkan wars in the

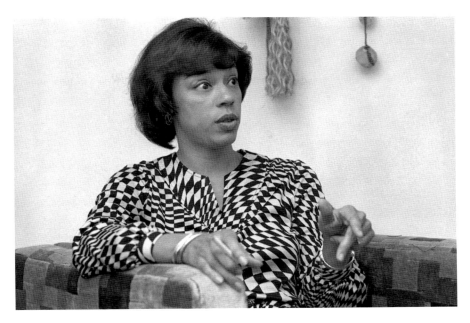

Judge Gabrielle McDonald was a founder and first president of the Black Women Lawyers Association. *Courtesy of* Houston Post *Collection (RGD0006N-3348-Fr11), Houston Public Library, HMRC.*

former country of Yugoslavia; from 1979 to 1999, she was president of the Tribunal. She has also served as judge of the Iran–United States Claims Tribunal arising from the 1979 hostage crisis at the U.S. Embassy in Tehran.

FIRST FEMALE JUSTICE ON THE U.S. SUPREME COURT: SANDRA DAY O'CONNOR (1930–)

She was the new kid on the block—especially when it came to gender.

Sandra Day was born in El Paso but spent much of her childhood and youth on the Lazy B, the family ranch in Arizona. She returned to El Paso for school, living with her grandmother while she attended the Radford School for Girls and Austin High School, graduating at sixteen.[44] At Stanford University, she studied economics (1950) with an eye to helping manage a ranch. But a dispute over a Lazy B cattle sale interested her in the law, so she returned to Stanford to earn her JD (1952) and was an editor for the prestigious *Stanford Law Review*.

Sandra Day O'Connor served twenty-five years on the U.S. Supreme Court. *Courtesy of Library of Congress Prints and Photographs Division.*

Sandra soon discovered that the glass ceiling for lady lawyers was as thick at California law firms as it was in Texas at the time. She entered public service as a deputy county attorney, married John O'Connor and followed him to Germany, where he was in the JAG Corps and she in the Quartermaster's Corps. On their return to Phoenix in 1957, Sandra opened her own firm but spent much time raising their three sons, born in quick succession.

In 1965, she became Arizona's assistant attorney general and followed that with a rapid rise. Appointed to fill an unexpired state senatorial seat, she won two more terms and, in 1972, became the first woman in the country elected a Republican Senate majority leader. After being elected to the Maricopa County state judgeship and appointed a year later to the Arizona Court of Appeals, it's no wonder that President Ronald Reagan named her to the U.S. Supreme Court in 1981, fulfilling a campaign pledge he'd made to place a woman on the country's highest court.

Sandra Day O'Connor retired from the bench in 2006 and since then has written two books on the Supreme Court to follow her memoirs of growing up on a ranch (2002). She's had many honors, among them the renaming of Arizona State University's Law School for her and her induction into the National Cowgirl Hall of Fame (see entry).

Chapter 8

LITERATURE

FIRST HISTORY OF TEXAS WRITTEN IN ENGLISH: MARY AUSTIN HOLLEY (1784–1846)

She's been called Texas's first press agent and first ambassador. Certainly, her books on the subject and her passion about building a future here made the land very attractive in many eyes.

Mary Austin was born in Connecticut, studied music and languages and grew up in a cultured and literate society. She married a minister and followed him to Kentucky, but on their return north, he died of yellow fever, leaving her with two young children (1827). Two years later, she moved to Louisiana to become a governess. Her brother Henry had joined their cousin Stephen F. Austin in Mexican Texas, and Mary yearned to go, too, so Austin reserved land for her on Galveston Bay. Mary made her first visit in 1831; the result was *Texas: Observations, Historical, Geographical, and Descriptive*, written in letter form and published in 1833.[45]

She also composed the "Brazos Boat Song," thought to have been the first musical composition in English written on Texas soil.[46] A children's book and several chapters of a novel flowed from her pen, too, "so much was [her] mind excited by this charming country."[47] She sent instructions to a cousin in New Orleans to begin negotiations for a book contract, certain she would make her fortune with a book that would be in much demand. Alas for Mary, she hadn't yet learned how little historians earn.

Mary Austin Holley's "Brazos Boat Song" was re-created for the Texas Centennial. *Courtesy of Special Collections, University of Texas–Arlington Library.*

Over the next dozen years, she made four trips to Texas, looking to sell parts of her land and gathering material for new books, including a biography of her cousin Stephen, who died suddenly in 1836. Her classic history, *Texas*—the first written in English—was published only months after Texas

won its independence at the Battle of San Jacinto. All eyes had been focused on the conflict, and Mary's book attracted yet more attention for Texas's prospects. She was very proud of her literary efforts, writing a cousin in 1844 that her name "is already associated with the Country as its first historian."[48]

In 1845, Mary Austin Holley returned to her Louisiana employers and died there of yellow fever.

FIRST LITERARY MAGAZINE IN TEXAS: MRS. ELEANOR SPANN (CIRCA 1791–1860)

"The editress," reported the *Dallas Herald*, "is said to be a lady of literary acquirements and cultivated tastes."[49] And the *Belton Independent* added that she was "a lady of mature years, accomplished and [of] exalted virtue."[50] She probably didn't much care for that word "mature."

The editress was Eleanor Crowley, a native of South Carolina who married Colonel C.S. Spann Jr. in Sumter in 1807 and bore him eight children. He died in 1834, but it was more than a decade before Eleanor's family moved to Washington County, Texas. She soon took herself, her daughter Mary and her slaves off to Galveston, where there was a bit more of a social life. And in either South Carolina or Texas, she earned a reputation as a French translator.

Eleanor Spann promised to "make my serial as good as Southern writers and Southern feelings and principles can make it." *Courtesy of Dolph Briscoe Center for American History, University of Texas–Austin.*

Eleanor borrowed money from several people, using city lots she owned in Galveston and slaves to secure them. She wound up in court more than once—even the Texas Supreme Court—because she felt she'd been taken advantage of as a widow and charged usurious rates. She sold at least two slaves to help settle debts but filed an injunction to stop another sale.

In July 1858, probably to raise money, she launched the *Texian Monthly Magazine*, a journal "*Devoted to Literature, Historical Romances, Original Tales, Incidents in the History of Texas, and Selections from the Most Approved and Popular Authors.*" There were French tales she'd translated, poetry, tidbits of national and international interest and articles from other writers. The *Texian* was about seventy-five pages long, and a subscription cost the equivalent of eighty-five dollars today. It gathered rave reviews as "the first effort made by a citizen of our State to establish a periodical worthy of public patronage."[51] It was also one of only a handful of such journals in the South.

Eleanor prepared at least four issues in 1858, her work slowed by a yellow fever epidemic that brought Galveston to a standstill. The last was to be published at Christmas, but it's not known if it ever was or if there were additional issues, as newspapers and residents were increasingly concerned with the possibility of war. Only two of the four issues are known to have survived.

Eleanor died not long after, probably in December 1860.

FIRST TEXAS HISTORY TEXTBOOK:
ANNA J. HARDWICKE PENNYBACKER (1861–1938)

"It is the attention we give to little things that proves our character," declared Anna Pennybacker. "So many of us fail with the petty details of life, that when a big opportunity comes along we are totally unprepared to meet it."[52] And Anna never missed an opportunity.

Born in Virginia mere weeks after the Civil War began, she came to Texas at seventeen and was in the first class to graduate from Sam Houston Normal School (now State University). It took only one year to earn a teacher's certificate, and she quickly became a student favorite for her sprightly presentations. Anna married Texas teacher Percy Pennybacker in 1884. The couple moved to Tyler, where Percy was school superintendent and she taught high school history.

Students and parents encouraged Anna to write *A New History of Texas for Schools*, privately published by Percy in 1888. Right up front in the preface, she stated her conviction that to successfully teach history demands not only

In 1918, Anna Pennybacker wrote, "I feel with all the strength of my woman's being that war is a relic of barbarism." *Courtesy of Texas State Library and Archives Commission.*

"a live [lively] instructor, but also a live text-book." Hers was filled with maps, illustrations, study games and snappy stories that imparted information without stupefying students. It was a hit, and Percy continued underwriting it until his death in 1899. The Texas Legislature adopted it as an official text, and it was used in state classrooms for forty years.

After Percy's death, Anna and her children moved to Austin. There, she became deeply involved in Woman's Club work, serving as president of the Texas Federation and two terms as head of the national organization (1912–16), where she oversaw the activities of one million women. She encouraged them to undertake a countrywide school and social hygiene program, the communal drinking cup being her particular *bête noire*.

Anna became a staple on the Chautauqua circuit, making several lecture tours a year and always spending time at Chautauqua's home in western New York. She met and became friends with Eleanor Roosevelt through her work with the Democratic Party. A pacifist dedicated to achieving international peace, Anna was a special correspondent to the League of Nations and urged the United States to join the World Court.

FIRST WESTERN NOVEL TO SERIOUSLY TREAT THE COWBOY: *THE WIRE CUTTERS* (1899) BY MOLLIE MOORE DAVIS (1844–1909)

Most people will say that the first real western novel was Owen Wister's famous *The Virginian*, published in 1902. But some Texas authorities will say the prize should go to a woman.

Mollie Evelyn Moore was a doctor's daughter, born in Alabama. The family settled in Texas in 1855, moving around from near Austin to Tyler and Galveston. Mollie was a prodigy who began writing poetry as a child and first published in the *Tyler Reporter* in 1860. Confederate Capt. Sid Johnson later recalled that, during the Civil War, she stood on the steps of the courthouse and presented a silk flag to Company K, Third Texas Cavalry, and then read a poem she'd composed. Mollie's work caught the eye of the editor of the *Houston Telegraph*, who took her under his wing and had her first book of poetry, *Minding the Gap*, published in 1867.

At the late age of thirty, Mollie married newspaperman Thomas Davis, and they moved to New Orleans, where she continued to write in many genres, the stories set in Texas or Louisiana. But her health suffered in the latter's humid weather, so she spent many summers on her brother's ranch in Comanche County, Texas. The drought of 1883, which unleashed the "Fence Cutting Wars," inspired one of her most famous books.

Throughout the West, cattlemen found their access to water blocked by new fences of barbed wire. In Texas, some of the worst resulting violence was in Coleman and Brown Counties. Mollie probably based her novel *The Wire Cutters* (1899) on a couple there who owned the largest fenced ranch in the state (seventy-eight thousand acres). When the husband died, his widow had to cope with the destruction on her own.

Mollie Moore Davis is now considered one of the more commercially successful southern writers, whose work appeared in book form, in newspapers and in magazines such as *Atlantic Monthly* and the *Saturday Evening Post*.

The Tyler chapter of the United Daughters of the Confederacy, established in 1898, is named for Mollie Moore Davis. *Courtesy of Smith County Historical Society.*

FIRST WOMAN'S NEWSPAPER IN TEXAS: MARY WINN SMOOTS (1868–1946)

She made her first career from a broadly comic, cornpone character and spent her second trying to get people to accept her as a serious writer.

Mary Winn was born in Georgia, the daughter of a Confederate surgeon. By 1880, the family was living in Sherman, Texas, where she attended North Texas Female College (later Kidd-Key) and began to write. Marriage to Charles W. Smoots and the birth of two children soon followed. It was not until the turn of the century that she developed the literary character for which she became famous, Aunt Lucindy Rainwater, with her broad, almost unintelligible dialect and pithy comments on current events.

By 1902, she and Lucindy were in newspapers and on the lecture circuit, with Mary giving readings in character. "Her impersonations of the mountaineer character, both in dialect and mannerisms, were perfect," wrote the *Daily Ardmorite*.[53] So closely identified with her character did she become—and remain for decades—that Mary Smoots was sometimes identified simply as "Aunt Lucindy."

Though she continued to pen Lucindy stories until the early 1940s, Mary soon moved to more serious ventures, writing for the *Sherman Courier*, becoming active in the Texas Woman's Press Association and League of American Pen Women and launching a weekly, *The Texas Woman*, in 1906. The first newspaper by and for the state's women, it was "bright and readable...Mrs. Smoots takes a cheerful view of life and its problems."[54]

She spent several years in Washington, "writing political dope," according to the editor of the *Texas Mesquiter*. Mary had commended the Republican

Mary Winn Smoots was a graduate of North Texas Female College, later Kidd-Key College, in Sherman. *Courtesy of Fort Worth Public Library, Local History and Genealogy Division.*

majority in Congress for voting down an amendment that would have made it unlawful for a congressman to accept a gift, free pass or corporate employment; the editor was outraged.[55] Mary also syndicated a column of interviews with prominent women and even "brought" Lucindy's husband, Jeems, to Washington for commentary.

Back in Texas, she was co-editor of the *Free Lance* (a politically oriented newspaper in Dallas), organized the Dallas Writers Club and wrote editorials supporting the Mothers' Pension Bill (1917).

First Female Poet Laureate of Texas: Aline Triplette Michaelis (1885–1958)

Born in St. Louis and educated there and in Kansas City, where she published her first poems, Aline Triplette made her way to Texas after marrying Fredrick G. Michaelis. Her poem "Courage" was so highly regarded that it was distributed to American forces overseas during World War I.

By the time Aline and Fred settled in Beaumont in 1919, she was already writing feature articles for newspapers around the state. She joined the staff of the *Beaumont Enterprise* and began producing a prodigious amount of material, including poems—more than ten thousand in her career—articles and even songs. In 1925, the Texas Legislature decided to choose a state song and invited entries. Aline and Lena Milam of Austin submitted "Texas," which made the top six but lost out to "Texas, Our Texas."

Aline's syndicated column, "The Rhyming Optimist," appeared in newspapers across the country. For it and other columns, she produced six poems a week from 1919 to 1935: that's more than five thousand poems written under the names Aline Michaelis and Susan Arnold Taylor, her pen name. In 1931, she published a book titled *Courage and Other Poems*. That brought her to the attention of the legislative committee determining the first state poet laureate. Aline lost to Judd Lewis of Houston but won two years later and became Texas's first female and second poet laureate.

Age is a deep pool, soundlessly
Shrining the hours that used to be,
Holding safe in its depths unstirred
Smiles long faded, long spoken word.[56]

Chapter 9

MEDICAL

FIRST FEMALE DOCTOR ADMITTED TO THE TEXAS MEDICAL ASSOCIATION: DR. FLORENCE E. COLLINS (1861–1914)

The Texas Medical Association was formed in 1853 but did not really function until 1869. Membership was open to "every gentleman of the Medical Profession."

But by 1887, women were beginning to invade the field. That year, Dr. Florence E. Collins, "an accomplished lady-graduate of Chicago" and secretary of the Travis County (Austin) Medical Association, boldly applied for membership. *Daniel's Texas Medical Journal* reported that the gentlemen members of the state association voted her in with a unanimous "rising vote," after which they all adjourned for peach ice cream and caramels. California was the first state to admit "Lady Physicians," but as *Daniel's* noted proudly, Texas was the first to do so without a dissenting vote.

First Licensed Female Pharmacist in Texas: Henrietta "Hettie" Manlove Cunningham (1852–1897)

Hettie Cunningham passed the state pharmaceutical exam the same year she bore her fourth child. That's one strong woman.

Hettie's family came to Texas from Indiana after the Civil War, and she married a Confederate veteran. James Cunningham had earned a medical degree but went into pharmacy instead, and he and Hettie opened their first drugstore in Waelder (east of New Braunfels). James became involved in a legislative campaign to regulate the rampant use of dangerous drugs and chemicals by those unqualified to handle them. Hettie successfully applied for her own pharmaceutical license in 1888 so she could run the drugstore and free her husband for this work.

In 1891, Hettie joined her husband as a member of the Texas State Pharmaceutical Association—its first and, for some years, only female member—and represented the association at its World convention in Chicago in 1893. She also served as an officer.

The Cunninghams later moved their business to Houston, where Hettie died in a yellow fever epidemic.

First Female Graduate of the University of Texas Medical Branch: Marie Philomene Delalondre Dietzel (1879–1958)

Marie Delalondre and the women who followed her faced an uphill battle at the University of Texas Medical Branch (UTMB).

The University of Texas opened its medical school in Galveston in 1891. The university never denied admission to women, but the year before Marie entered, its president declared—before an audience of female writers—that "the work of a doctor or surgeon is not the work for a woman. Because she is naturally a good nurse is no reason why she should cease to be the nurse and become the physician…love [of caring for patients] must be the motive, not a fee. [When we are in pain,] we want in woman 'a ministering angel,' not an attending physician."[57]

Marie was born in New Orleans but grew up in Galveston. In spite of the prevailing environment, she graduated from the Medical School in 1897,

Marie Delalondre's 1897 diploma from the University of Texas Medical Branch at Galveston. *Courtesy of Truman G. Blocker History of Medicine Collections, Moody Medical Library, University of Texas Medical Branch.*

the only woman in her class of thirty-three. Dr. L.W. Payne, the head of the school, expressed his pleasure at seeing her on graduation day: "We have here to-night another evidence of our modern civilization. Men have been wont to think of women as the weaker vessel but…woman is not only to minister to the wants of men with tenderness and care, but she is here to share with him all that science offers."[58]

Applause greeted his remarks, and, as he presented Marie, he added, "This is the first occasion on which [women] have been recommended for degrees. It is a source of gratification that the young lady…is a modest and gentle lady, yet brave and independent."[59] He then withheld her diploma because she was only eighteen and not yet "of lawful age." But Marie had already registered as a physician with Galveston County and soon opened her practice at Twelfth and Market Streets near the Medical School. In 1906, she married Arthur Dietzel and moved her office to his home, where she continued to practice medicine until 1918.

Marie Dietzel died one year after attending her fiftieth reunion at the Medical School.

FIRST FEMALE FACULTY MEMBER AND PROFESSOR AT UTMB: MARIE CHARLOTTE SCHAEFER (1874–1927)

Her students called her "the old lady" and knew she demanded only their best work. Faculty found her pleasant and enjoyed watching the improvements she made to her office and lab—as well as toys for her sister's children—with her carpentry tools.

Charlotte Schaefer was a native of San Antonio and taught there for a year after high school. In 1895, she entered the Medical School, where she and one other woman received their MDs in 1900. Among the class's top six graduates, Charlotte was given a one-year residency at John Sealy Hospital, the school's training facility for both doctors and nurses.[60] She completed further studies at the University of Chicago and Johns Hopkins. On her return to Galveston in 1901, she was invited to join the faculty as a "demonstrator" in histology (the microscopic study of plant and animal tissue in minute detail). Charlotte moved up through the ranks, becoming the Medical School's first female professor in 1925.

Dr. Charlotte Schaefer was first head of the Department of Histology and Embryology at UTMB in 1912. *Courtesy of Truman G. Blocker History of Medicine Collections, Moody Medical Library, University of Texas Medical Branch.*

One of her most important contributions was research on hookworms. This parasite is rare today in the United States but was rampant in the warm, humid and largely poverty-stricken South of the late nineteenth and early twentieth centuries. The creature looks like a worm with a set of teeth you don't want to meet.

Charlotte worked at the Medical School with a pioneer in this research, Dr. Allen Smith, but subsequently did her own studies when the worm

turned up in several students and in cases brought to the infirmary. Her paper on the subject at the 1900 Texas Medical Association meeting was the first time a woman had presented there; it was published in 1901.

Charlotte died suddenly of a heart attack the day before the school's 1927 graduation. At the funeral in San Antonio, former students carried her coffin to the grave site.

First Anglo Female Dentist in Texas/First Black Female Dentist in the United States: Dr. Jessie Estelle Castle (La Moreaux) (1866– 1954)/Martha Jordan

The first dentist in Texas may have been a young Virginian who volunteered in the Revolution and died here in 1836. But the first Anglo female dentist was a feisty young woman from Battle Creek, Michigan.[61]

Jessie Castle began teaching third-graders at age seventeen. At some point, she decided to become a dentist and entered the College of Dental Surgery at the University of Michigan—where she was a "universal favorite"—and graduated three years later with a DDS, the only woman of the three in her class to finish the course. Postgraduate work there "very thoroughly equipped [her] for the dental profession."[62] She practiced for several years at the Battle Creek Sanitarium and then moved to Dallas in 1898 to be near her sister.

That same year, she met and married Frank La Moreaux, but after their divorce in 1901, Jessie moved her office to Rockwall (east of Dallas) and lived with her sister and brother-in-law. Their home is now the Rockwall County Historical Foundation headquarters, where many of Jessie's belongings are exhibited, including her fearsome-looking dental drill and the riding habit she wore while bicycling. Also in the archives is a letter from Jessie to her parents, telling them of the physical pain she suffered from the exertions of her work.

Among Jessie's classmates at Michigan's dental school was Martha Jordan, a young black woman from Dallas. She attended the University of California and then returned to Dallas to teach school, presumably to make enough money to enter the Dental College at Denver University (now University of Denver) in 1892 "to fit herself for a first class dentist. Miss Jordan [was] the first colored person to enter this department of the university."[63] This was big news, and a brief announcement appeared in newspapers across the

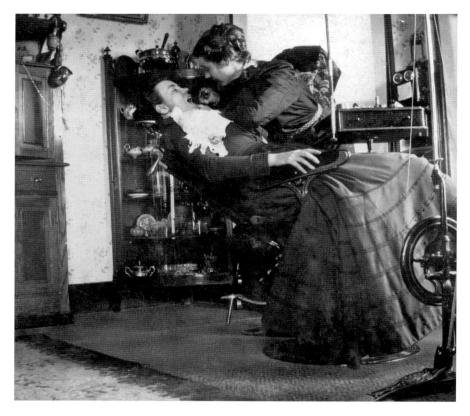

Dr. Jessie Castle (La Moreaux) in her Dallas office, circa 1900. Note her drill, sitting on the floor, in the right side of the picture. *Courtesy of Rockwall County Historical Foundation.*

country and even in Australia. You might think she would have suffered from harassment, but she didn't, although a black male classmate did.

Martha transferred to Michigan in 1893 with Jessie Castle's class but apparently did not finish her degree. She set up a practice in Dallas, but little else is known about her.

FIRST WOMAN LICENSED TO PRACTICE DENTISTRY IN TEXAS: DR. MARY LOU SHELMAN (1866–1955)

You might be confused—wasn't this Jessie Castle? Jessie didn't require a license to practice in Texas because she was a graduate of a recognized

dental college. Like lawyers, however, aspiring dentists at the time could learn by apprenticing and/or studying on their own and then taking a four-day exam.

"Dr. Mary," as she would be known to her patients, probably did both. She must have been a fast learner; after attending one convention, she made a pair of dentures for herself that lasted twenty-five years. She followed this with years of study at schools in Chicago, Dallas and other cities; at conventions that offered classes; and with specialists in areas such as orthodontics (so she could make her daughter's braces).

In 1898, when Mary received her certificate, her choices for cities where she could open an office were few, for who wanted a female dentist? Not cities, where there were many men practicing. So Mary mapped out two regions to survey, one roughly south of today's I-20, between Abilene and Hamilton, and the second at Canyon. Over the years, she moved between Canyon—where she treated World War I soldiers—Rising Star (south of Cisco) and Cross Plains (to the west).[64] She bought a buggy, a sturdy black horse and a Harrington & Richardson pistol, which traveled with her on house calls. In Rising Star, she married Samuel Graves, but they divorced in 1913 after having one daughter, whom Mary raised.

Mary had no assistant and made all her patients' crowns, bridges and dentures. The physical toll of the profession, the constant moving in search of patients and the strain of being a single mother played havoc with her health. Yet Dr. Mary practiced for fifty-four years.

FIRST WOMEN TO INTERN AS DOCTORS AT UTMB: EDITH MARGUERITE BONNET (1897–1982) AND FRANCES VAN ZANDT

Edith Bonnet grew up in Eagle Pass on the Rio Grande southwest of San Antonio. She matriculated at the University of Texas, intending to study architecture, as her mother wished, but switched to science. She must have done well; in 1922, she was accepted immediately into what was by then named the University of Texas Medical Branch in Galveston.

The school had a high attrition rate because of the difficulty of the classes. Edith herself found it hard going, as she recorded in her diary her freshman year: "Failed in a Materia Medica[65] quiz and am doing very poorly in Anatomy and Chemistry. It's baffling to work hard and get nowhere."[66]

Edith Bonnet's diary and oral history are in the UTMB Archives. *Courtesy of Truman G. Blocker History of Medicine Collections, Moody Medical Library, University of Texas Medical Branch.*

Despite the successes of earlier female students at UTMB, Edith also suffered discrimination because she was a woman. On graduating in 1926, she and Frances Van Zandt, as top graduates, were offered internships at John Sealy Hospital. But the Sealy board vigorously objected to women working in the male wards for urology classes. Edith and Frances tried to find solutions, but no avail. Frustrated, they turned to the state's highest authority and first female governor, Miriam Ferguson (see entry), who agreed with their argument that a state institution could not discriminate against women.[67]

Edith had hoped to study pediatrics at Harvard after her internship but was told women were not admitted because there was no proper housing

for them. So it was on to Children's Memorial Hospital in Chicago, where she stayed four years. Edith opened an office in San Antonio in 1933 and practiced pediatrics until retirement. She spent much of her time in the poor, violent and largely Hispanic West Side but was never bothered—everyone knew she was there to save babies.

Even after officially retiring, Edith Bonnet continued to work at area clinics until unable to read street signs and drive safely.[68]

First Black Nurse to Earn Master's in Nursing from Columbia University/First Black Nurse on Board of American Nurses Association: Estelle Massey Riddle Osborne (1901–1981)

Estelle Massey was born into a large family in Palestine in East Texas. Her mother, a domestic for white residents of the town, refused to allow her daughters to do the same, wanting to shield them from racial prejudice. Like the poor parents of other women in this book, Estelle's were uneducated, making them doubly determined to see all their children in school. And Estelle exceeded their greatest hopes.

She graduated from what is now Prairie View A&M and taught in a one-room school. Estelle considered entering dentistry but finally decided on nursing and graduated in 1923. Four years later, after working or teaching in several cities, she began studying for her BS in nursing at the Teachers College of Columbia University, achieving that degree in 1929 and her master's in 1931. She worked at Freedman's Hospital at Howard University and then returned to her first hospital as its director of nursing. In 1934, she was elected president of the National Association of Colored Graduate Nurses.

During World War II, Estelle worked successfully to change discriminatory practices in America's nursing schools and to get black nurses into military service. Afterward, she joined the nursing faculty at New York University— becoming its first black member—and in 1948 was elected to the board of directors of the American Nurses Association, a previously white organization. When it merged with the "colored" nurses association, Estelle, who was on the boards of both, had already laid the groundwork for the transition.

Ironically, she was targeted in 1950 by the House Committee on Un-American Activities for her membership in the Congress of American Women, a women's and civil rights group that dissolved that same year.

Estelle Osborne received many honors over the years, including induction into the American Nurses Association Hall of Fame.

FIRST FEMALE PRESIDENT OF THE TEXAS SOCIETY OF PATHOLOGISTS AND THE TEXAS MEDICAL ASSOCIATION: DR. MAY OWEN (1891–1988)

It would take most of this book just to list all her honors and awards. Thousands of Texans in medical fields owe their educations to her, and more have rejoiced in the music of the Texas Boys Choir, which she helped bring to Fort Worth. Even sheep and cattle owe their lives to her. But she considered herself simply a "microbe hunter."[69]

May Owen was born on a hardscrabble farm near Marlin where everyone worked, even two-year-old May. A childhood bout with polio caused the muscles in one shoulder to atrophy but never stopped her. Her particular joy was to "doctor" the animals. Poverty and her father's dislike of educated women might have kept her on the farm had not an elder brother paid for high school in Fort Worth. After graduation, she found a job and a mentor in Dr. T.C. Terrell's laboratories.

The only medical school that would admit her was in Louisville, Kentucky, where May became the first female student in 1917 at the age of twenty-six. The flu pandemic that began the next year persuaded her to change from general medicine to pathology, the study of diseases. Over the following years, May did postgraduate work at the Mayo Clinic and Bellevue Hospital in New York City, among other institutions.

But she always returned to Fort Worth and Terrell Labs, where she conducted some of her most important research. Her experiments in 1935 and 1936 showed that a certain type of talcum powder commonly used in surgeons' gloves caused inflammation and scar tissue if accidentally dislodged into surgical wounds. That published research saved many lives.

As in her childhood, sheep and cattle were among her patients, too. It was May who discovered that feedlot sheep developed diabetes from a certain feed (1931) and that cattle were sickened from mineral and machinery oil that dripped into feed being processed (1953). She became such a respected figure that she was made an honorary member of the American Veterinary Association (1963), but not before contracting typhus from an animal.

Dr. May Owen, incoming president of Texas Medical Association, accepts the gavel from outgoing president, Dr. Franklin Yeager (right). *Courtesy of* Fort Worth Star-Telegram *Collection, Special Collections, University of Texas–Arlington Library.*

May's real joy came from helping others get an education. Countless Texas students received her personal loans for tuition, and she endowed both a chair in pathology at Texas Tech (1974) and a nursing scholarship at Tarrant County Junior College, where she was the sole woman on the first board of trustees. In 1960, she became the ninety-fifth and the first female president of the Texas Medical Association. One of her first actions was to turn down the annual travel allowance and use it to start a benevolent fund for doctors and their families.

At the age of eighty-seven, despite broken hips and osteoporosis, May began work for a Dallas lab to consult with seven hospitals outside Fort Worth. Three years later, she was named an adjunct professor at Tarleton State College. When finally forced to move to a convalescent home, she

refused to stay, saying she didn't want to be with old people who had given up. A residence was prepared for her at All Saints Hospital, where she died just short of her ninety-seventh birthday.

Dr. May Owen had worked—as usual—the day before.[70]

FIRST FEMALE PEDIATRIC SURGEON IN TEXAS: DR. BENJY FRANCES BROOKS (1919–1998)

Her first surgeries were on her sister's dolls. And she learned to read long before she was old enough for school. Benjy Brooks knew that, if you were a Texan, there was no limit to where you could go.[71]

She was born in Lewisville, then a small farming community southeast of Denton. But the family moved to Martha, Oklahoma (west of Lawton), where they were living when Benjy enrolled at North Texas State Teachers College (now University of North Texas) in Denton. She wrote poetry for the college magazine and majored in chemistry, precociously graduating at nineteen (1938) and immediately returning to NTSTC for her master's (1940).

Dr. Benjy F. Brooks (second from left) was the first woman to receive the Distinguished Alumnus Award from the University of North Texas. *Courtesy of* Houston Post *Collection (RGD0006N-1980-0586Fr02), Houston Public Library, HMRC.*

Benjy taught high school for four years and, when she'd saved enough, enrolled at UTMB in Galveston, receiving her MD in 1948. From there, she never stopped, with residencies in Boston, Philadelphia and Harvard, where she was the first woman appointed to pediatric surgery. She spent a year studying in Glasgow, Scotland, and even served in the U.S. Navy Medical Corps Reserve. When she returned to Texas in 1958, it was as the state's first pediatric surgeon.

One of her important medical achievements occurred at Harvard in 1953, when she and two other doctors discovered the potency of gamma globulin in treating yellow jaundice (infectious hepatitis) in families. Another came in 1965, when she

Dr. Nancy W. Dickey was the first woman to be president of both the American Medical Association and the Texas A&M Health Science Center. *Courtesy of Texas A&M University Health Science Center.*

was the only woman on a team that separated nine-week-old conjoined girls, the first such surgery in Houston and only the tenth in the United States.

Over the years, Benjy taught and practiced at a prodigious rate. She was on the staff of or had privileges at more hospitals than you can count. She received scores of awards and honors, and today there are a foundation and several endowed scholarships in her name that will help others carry forth the care of Texas children.

Chapter 10

MILITARY

ONLY FEMALE MEMBER OF THE GRAND ARMY OF
THE REPUBLIC/ONLY WOMAN IN THE CIVIL WAR
GIVEN A SOLDIER'S PENSION: SARAH EMMA EVELYN
EDMUNDSON [EDMONDS] SEELYE (1841–1898)

Although this woman did not spend a good part of her life in Texas, she made this her last home, and her bones rest here.

Sarah grew up in Nova Scotia, the daughter of a man who'd wanted a son and so treated her like one. As a teenager, she ran away from home, using the male disguise to which she was accustomed. For a time, she traveled as "Frank Thompson," a Bible salesman. In 1861, she heard about Lincoln's call for soldiers and journeyed to Washington, D.C., to see how she could help.

Sarah spent months in Washington and Virginia as a field nurse and was at Bull Run/First Manassas. Numb from the horror of the battlefield, she accepted an opportunity to spy for the Union.[72] For two years, in between serving as a male nurse in the Second Michigan Infantry, she made eleven forays across enemy lines, dressed as everything from an Irish peddler woman to a young black man. "I am naturally fond of adventure," she admitted in her book, *Nurse and Spy in the Union Army*.

After Vicksburg, suffering from repeated malaria and fearful of going to a hospital where her gender would be discovered, "Frank Thompson" deserted, and Sarah Edmundson returned to Washington to be a nurse once more. In 1864, she wrote her story and donated most of the proceeds to war

relief. She married a fellow Canadian, Linus Seelye, and eventually settled in La Porte, Texas, today a suburb of Houston.

In 1884, she communicated with her former U.S. Army comrades, who sent her money to attend their next reunion. To their surprise, "Frank Thompson" was now an elderly matron. And because Frank had been listed as a deserter, Sarah could not claim a military pension. The Grand Army of the Republic lent a hand; "Frank's" name was cleared, and Sarah received her pension, joining the George B. McClellan Post in Houston.

Sarah died before completing her war memoirs and "was buried at a lonely spot by the seaside."[73] In 1901, the Houston GAR moved her body to Washington Cemetery, where its members could keep watch over her.

FIRST WOMAN TO WIN THE SILVER STAR IN WORLD WAR II: MARY LOUISE ROBERTS WILSON (1914–2001)

Friends at work called her "Pinky" for her red hair. But wounded soldiers lying on operating tables looked up into her calm, sweet face and called her the "Angel of Anzio."

Mary Roberts grew up in Lufkin, but her family moved to Mississippi to live with relatives after her father's death. Knowing she had to help support them, she earned her nursing degree from the University of Alabama (1935). A few years in a New Orleans hospital led her to Dallas, where she worked in surgery (1939). In May 1942, Mary enlisted as an operating room supervisor in the U.S. Army's Fifty-sixth Evacuation Hospital, formed by Baylor Hospital.

After months of training, the unit—supporting Lieutenant General Mark Clark's Fifth Army once it reached Italy—went to Casablanca in North Africa (April 1943) and then drove 120 trucks overland to Bizerte, Tunisia, where members first came under enemy fire while treating casualties of the Italian campaign. From there, they followed the troops to Sicily and up the boot of Italy to Paestum (south of Naples). Constant bombardment hounded the unit to Anzio (late January 1944). Its amphibious vehicle was attacked by Germans while landing, as were the trucks carrying them to the field hospital, despite the clear hospital markings.

Within thirty-six hours, they were operating in a small city of tents—soon dubbed Hell's Half Acre—and blessedly unaware that ten weeks of shelling lay ahead of them. Mary Roberts and her nurses worked twelve-plus-hour

shifts around the clock. On February 10, 1944, German shrapnel ripped through the tent she supervised, further wounding two soldiers and killing a nurse. Though her first thought was to hide under a table, Mary calmly directed the removal of patients onto the floor and continued their care, all by flashlight. "We just kept on working," she said later.[74]

"For calmness during the battle" and for gallantry, Mary and three other nurses were presented the Silver Star. Since she was the senior officer, Mary's award was given first, making her the first woman in World War II to be so honored.[75] The women still wore their operating gear and immediately returned to work.

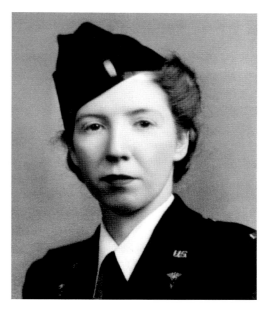

Two hundred army nurses, including Mary Louise Roberts (above), served at Anzio; six were killed. *Courtesy of* Fort Worth Star-Telegram *Collection, Special Collections, University of Texas–Arlington Library.*

The Fifty-sixth—having treated more than seventy-seven thousand soldiers—was in Bologna when the war ended in Europe. Mary returned home to Dallas in 1946 and, after a rest, went to work in the surgery unit of the city's Veterans Administration hospital. She married a fellow vet and retired from the VA in 1972.

When television journalist Tom Brokaw wrote *The Greatest Generation* in 1998 and included a chapter about her, Mary's quiet life in Duncanville, Texas, was never the same.

FIRST FEMALE WARTIME RADIO CORRESPONDENT/ FIRST FEMALE REPORTER AT WAR CRIMES TRIALS: KATHRYN COCHRAN CRAVENS (1898–1991)

"I was sued, shot at, and suspended, but never scooped," she once said.[76] A reporter can't ask for more than that.

Kathryn Cravens signs her novel, *Pursuit of Gentlemen*, based on an ancestor's diary. *Courtesy of* Fort Worth Star-Telegram *Collection, Special Collections, University of Texas–Arlington Library.*

The bright lights of New York and Hollywood were far away when Kathryn grew up in Burkett, a hamlet near Abilene. She left as soon as she could, studying art and drama at schools in Kansas, Missouri and New York City. Next came Hollywood and a brief stint in silent films.

But when a St. Louis station hired her in 1923 to "act" on the radio, Kathryn found her niche. She took her husband of six years, R.R. Cravens,

with her. (They would divorce in 1937, when, to his dismay, her career took off.) In 1931, she sold her producers on the idea of her own signature show, *News Through a Woman's Eyes*, a mash-up of news relevant to women and gossip about the glitterati. CBS Radio in New York City picked her up in 1936; next was a syndicated newspaper column of the same name. Kathryn was now a celebrity, doing promotions for companies such as Pontiac. In 1942, she moved to New York and became the first female radio commentator and news reporter in the country to broadcast nationally.

In October 1940, with war approaching, Kathryn challenged American women to help stop the horror in Europe, where "bombs hurled from the heavens demolish towns…[where] starvation is creeping…slowly, relentlessly…[and the United States] is in the path of the storm that threatens to engulf the entire world."[77]

Toward the end of World War II, Kathryn "became the first woman accredited as a wartime radio correspondent when she was assigned to cover Europe, Asia, and the Middle East."[78] She entered Berlin with Allied troops in 1945—the first woman to do so—but was arrested at the Potsdam conference for sneaking in before Allied leaders arrived. For her work, she received a citation from the U.S. Army. After the war, she covered international stories in the Balkans and the Middle East and interviewed four presidents.

Kathryn returned to the family home in Burkett in 1962 and lived there until her death.

Chapter 11

NATURAL

SMALLEST STATE PARK IN TEXAS: ACTON STATE HISTORIC SITE (1949) AND ELIZABETH PATTON CROCKETT (1788–1860)

To those accustomed to Texas's other parks—say, Caprock Canyons, at 15,313 acres—a park of only one-hundredth of an acre or less might seem pretty small. But a monument of Texas granite there guards the grave of a legendary figure.

David Crockett's amazing life ended in San Antonio at the Alamo on March 6, 1836.[79] Back in Tennessee, his wife, Elizabeth, probably didn't hear of his death for weeks. When she did, she donned black once more for a dead husband and never wore colors again. David had intended to move his family to Texas, the garden spot of the world, he'd told them. But not until 1854 did Elizabeth, her son Robert and his wife make the long journey by covered wagon to Ellis County (south of Dallas), where they stayed for two years, presumably to search for land.

Because her husband had fought in the Texas Revolution, Elizabeth was entitled to his land grant of 640 acres. She and Robert selected Acton, a settlement southwest of Fort Worth and the oldest in what is now Hood County. It was wild country then, and the Crocketts were among the earliest white settlers. Half their grant went to pay the surveyor. The rest they located on Rucker's Creek, east of the Brazos River (now Lake

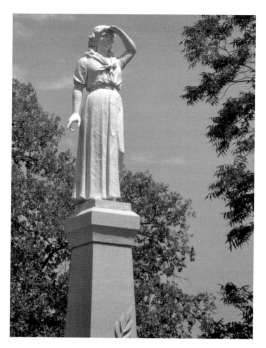

Both David Crockett and Elizabeth Patton were widowed when they married each other in 1815. She is buried in Acton, Texas; the location of his remains is unknown. *William R. McLeRoy.*

Granbury); a granite slab marks the site where Robert built a two-room log cabin in a grove of live oak trees.

When Elizabeth died in January 1860, she was buried in the Acton Cemetery. Robert and his wife would later be laid next to her.

But in 1910, two Texas legislators decided that Elizabeth's grave needed to be marked since David's never could be. Two thousand dollars was appropriated to sculpt from Texas granite the statue of a woman said to bear Elizabeth Crockett's features and to mount it atop a column over her grave, the whole being twenty-eight feet high. She looks west, watching for the husband who never came home. The sculpture was dedicated in May 1913 and unveiled by her great-granddaughter.

The Crockett grave site was made a state park in 1949 and transferred to the authority of the Texas Historical Commission in 2008.

FIRST TEXTBOOK ON TEXAS BOTANY: MATILDA JANE "MAUD" FULLER YOUNG (1826–1882)

Maud Young had a long and successful career as an author and poet before she wrote the subject of this entry. Born in North Carolina, a descendant of John Rolfe and Pocahontas, she moved with her family to Houston in 1843. Largely self-taught, she read avidly and studied chemistry. Her marriage to Dr. S.O. Young lasted only nine months before he died of yellow fever, after which Maud raised their son in her parents' home.

When war tore the country apart in 1861, Maud's passion was the Confederate cause. She wrote endless poems and articles for the *Houston Telegraph* that glorified the South. Her son fought in Hood's Texas Brigade; she made a flag for the brigade that today is in the Texas State Archives and raised many thousands of dollars for the unit and the Confederacy. Even when Lee surrendered in 1865, Maud refused to give up. With Gen. Kirby Smith and several other high-ranking officers, "the Confederate Lady" wrote to the "Soldiers and Citizens of Texas, New Mexico, and Arizona." The broadside "was distributed through the army during the dark days after Lee's surrender, when it was still hoped that Texas would constitute herself the bulwark and refuge of that cause."[80] Maud's later prose poem, "The Legend of Sour Lake," was a disguised tale of the Confederacy.

Maud had taught briefly before the war, and she now returned to the classroom. Botany had always been one of her favorite subjects, and the Young home in Houston was known for the gardens she created and used for botanical experiments. Her book, *Familiar Lessons in Botany, with Flora of Texas* (1873), was an outgrowth of her classroom. It is a remarkable book, and not just because it was the first textbook on Texas's abundant plant life. Maud was a botanist, but she was also a writer who wanted to excite her students. She told stories about plants and used rich, descriptive prose to help them truly see, describing algae, for example, as being "like yards of finest Florence silk, green, purple, and crimson."[81] The downy-soft cottonweed seed was exemplary of how plants spread. So "myriad seeds are doing for the whole globe, causing the barren places to rejoice and the desert to bloom like a garden."[82] Acclaimed botanist George Engelmann of St. Louis praised *Familiar Lessons* and Maud's courage in writing it with so little formal training.

From 1872 to 1873, Maud Young was the state botanist of Texas. She amassed a fine herbarium collection of Texas ferns and flowering plants, but it and most of her writings were lost in the Galveston Storm of 1900, almost two decades after she died.

FIRST STATE PARK IN TEXAS: MOTHER NEFF STATE PARK (1938) AND ISABELLA SHEPHERD NEFF (1830–1921)

Texas's remarkable variety of environments is showcased today in its ninety-three state parks, historic sites and natural areas, totaling nearly 600,000

The first Texas Parks Board members were charged with finding donated lands for parks and negotiating options to purchase other properties. *Photo 1963-283-057, Texas State Library and Archives Commission.*

acres. The largest park is Big Bend Ranch (301,319 acres), and the smallest is Acton State Historic Site (see entry).

But it all began with a gift of six acres from Isabella Shepherd Neff.

Isabella and her husband came to Texas from Virginia in 1854 and settled in what is now Coryell County (west of Waco) on the Leon River. There, they raised nine children of their own and three orphans they took in, leading to Isabella's nickname of "Ma" Neff. Their youngest, Pat, was elected governor of Texas in 1921; Isabella, then ninety, joined his family in the Governor's Mansion—a far cry from the family's first log house on the frontier.

After her husband died in 1882, Isabella allowed public gatherings on a few acres along the river, a place with ancient trees, steep bluffs down to the water and even Indian caves. At some point, while making her will, she decided to deed the site to the state so that it might continue to be used for that purpose. When she died in 1921, Pat honored her wishes and deeded the property to the state, naming it Mother Neff Memorial Park. He later donated another 250 acres.

The governor and others realized they had stumbled on a great idea, and in 1923, the Texas State Park Association was organized to encourage and

assist in the development of a state parks system. The legislature passed a bill authorizing a state parks board but—ahem—failed to appropriate any money for it, so the first parklands were donated. As Neff bluntly stated, "We haven't a dime to pay for them."[83] But in less than a year, there were fourteen sites.

By then, people were fanning out across the state, looking for sites. Neff's goal, and that of the new park board (which took over from the association), was to have a state park for every hundred miles across Texas—"breathing spaces for the enjoyment of present and future generations."[84]

Mother Neff State Park was dedicated in 1938 after years of improvements made by the Civilian Conservation Corps. Though it was not the first to open, it is considered the first park, the impetus that established what is now the Texas Parks and Wildlife Department.

FIRST WOMAN TO WIN THE ASTRONOMICAL LEAGUE OF AMERICA'S OUTSTANDING ACHIEVEMENTS AWARD: CHARLIE MARY NOBLE (1877–1959)

Charlie Mary Noble took Fort Worth kids on a "star trek" long before Gene Roddenberry did.

Charlie's family moved from Giddings (east of Austin) to Fort Worth in 1888. She received her BS from the University of Texas and her MS from Texas Christian University and remained in Fort Worth the rest of her life, teaching and sharing with others her love of science. Charlie taught at what is now Paschal High School for forty-six years, twenty-five of those as head of the math department. Her passion was astronomy, and she often took students out for "night classes" to observe the sky and how the two subjects were related.

Charlie also volunteered at the Children's Museum (now Fort Worth Museum of Science and History), where she organized one of the first Junior Astronomy Clubs (1947). But Charlie's kids did more than just look through telescopes. In the Sputnik era of the late 1950s, they tracked satellite positions to help scientists determine their orbits. The parents of these junior astronomers became so interested that they launched an adult club in 1949.

That same year, Fort Worth's Junior League contributed $1,000 to the Children's Museum for a Spitz A-1 Starball planetarium to aid Charlie's work, making it the first such museum in the country to have one. (It's still

Charlie Mary Noble (left) explains the workings of the Fort Worth Children's Museum planetarium projector, 1949. *Courtesy of* Fort Worth Star-Telegram *Collection, Special Collections, University of Texas–Arlington Library.*

in the museum's collection.) A dome was built in the backyard to house it. Charlie established a library in her home, where her kids could check out telescopes rather than books. Fort Worth's Junior Astronomy Club became so well known that Charlie's procedures became the national model.

During World War II, she taught celestial navigation and related classes to U.S. Navy V-12 officers training at TCU; after the war, she taught astronomy, too.

Charlie received many honors, the most prominent of which was the Charlie Mary Noble Planetarium at the Children's Museum—the world's first named for a woman—in 1955. It still bears her name. The following year, she was the first woman honored for her outstanding achievements by the Astronomical League (of America).

LARGEST RESEARCH LIBRARY AND ONLINE DATABASE ON NATIVE PLANTS: LADY BIRD JOHNSON WILDFLOWER CENTER (1982) AND LADY BIRD JOHNSON (1912–2007)

She was the "Environmental First Lady." And springtime in Texas is even more glorious because of her.

Claudia Taylor "Lady Bird" Johnson grew up in Karnack on the cypress bayous of Caddo Lake and the pine forests of East Texas. She attended a junior college in Dallas but couldn't decide whether to continue her education in Alabama or Texas. A trip to Austin in spring bluebonnet season settled the question and started her on a lifelong quest to protect the natural beauty of both Texas and America. She earned two BAs at UT and planned to become a journalist.

But a date with Lyndon Baines Johnson changed her life. (He famously proposed on their first date.) As he forged his political career, Lady Bird built their financial future by investing in radio and television stations. And she stood beside him on Air Force One when he was sworn in as the thirty-sixth president of the United States (1963).

As First Lady, she had the leverage of the White House to embark on her beautification campaign, which changed America. And to Lady Bird, "beautification" was not just planting flowers but also confronting every blight from pollution to crime. If flowers could bloom in a spot, she declared, so could hope. She began with the Society for a More Beautiful National Capital, and you can still see the results when you visit Washington. She

Lady Bird made the Johnson administration the most conservation oriented since those of Teddy Roosevelt and Franklin D. Roosevelt. *Courtesy of Library of Congress Prints and Photographs Division.*

The Lady Bird Johnson Wildflower Center maintains a huge database on Texas's abundant wildflowers. *William R. McLeRoy.*

campaigned for the Beautification Act of 1965—"Lady Bird's Bill"—which limited billboards and promoted planting on the nation's highways. A descendant of that bill is the 1987 highway bill requiring that a minimum .25 percent of road construction funds go toward landscaping.

Another of her legacies is in Austin. She and actress Helen Hayes established the National Wildflower Center in 1982 with her gift of sixty acres in east Austin, $125,000 and a mission to protect and preserve native plants—not just in Texas but across the country as well. By 1995, the Center was so successful that it moved to a site just off the new Capitol of Texas Highway. Two years later, the name was changed to the Lady Bird Johnson Wildflower Center.

In 2003, the online Native Plant Information Network (NPIN) was launched and today has a database of nearly eight thousand plants from across North America (not just the United States) and more than thirty-five thousand images. The Center also promotes water conservation with its Drought Resource Center and, at one time, had the largest rainwater collection system in the country. The Center is now a research unit of the University of Texas.

Chapter 12

RANCHING AND FARMING

FIRST CATTLE QUEEN OF TEXAS/LARGEST LANDOWNER IN TEXAS: ROSA MARIA HINOJOSA DE BALLI (1752–1803)

You probably know the old saying that behind every successful man is a woman pushing him. But sometimes, when the men died or moved on, those women got a chance to shine on their own. Such was the case with Rosa Maria Hinojosa de Balli, born in Reynosa, Mexico, of aristocratic Spanish parents.

In 1752, when Maria was born, "Texas" belonged to Spain and was in the province of Nuevo Santander, settled by her parents and other Spaniards.[85] They mostly lived south of the Rio Grande River, but their ranches, bestowed through royal land grants, lay to the north. Maria grew up in Reynosa (south of McAllen) and married Capt. Jose Maria Balli in 1772. He and her father applied for several land grants in the La Feria section of what are now Cameron and Hidalgo Counties in Texas, but both died before the transactions were finalized in 1790. Maria inherited Jose's debts and his share of the land—nearly fifty-five thousand acres.

That was only the beginning. In the remaining thirteen years of her life, Maria cleared all her husband's debts and acquired one million acres covering most of five modern counties and encompassing a third of today's Lower Rio Grande Valley, including the land on which Harlingen now sits.

This bronze sculpture of longhorn cattle being herded is located near Fort Worth's famous Stockyards and Billy Bob's Texas. *Ann McLeRoy Photography*.

Because Spanish law allowed her to inherit but not to apply for land grants in her own name, she did so in her sons' or brothers' names, after which they would transfer the properties to her. Among those grants was Padre Island, which she jointly applied for with her son, a priest; Maria later withdrew her name in favor of her grandson.

"La Patrona" lived in Reynosa Viejo, close to the Rio Grande, but ran operations from various ranches on the Texas side of the river.[86]

FIRST WOMEN TO MAKE THE DRIVE UP A CATTLE TRAIL: HARRIET STANDEFER CLUCK (1846–1938) AND AMANDA NITES BURKS (1841–1931)

Harriet and Amanda will have to duke it out over which one was first up the Chisholm Trail to Kansas, because they were both there in 1871.[87]

Amanda's husband requested that she join him at the last minute. She traveled in her own buggy and was able to enjoy long naps as the horses faithfully followed the cattle. The Burkses trailed about one thousand head,

The longhorn herd in the Fort Worth Stockyards takes part in the world's only twice-daily urban cattle drive. *Ann McLeRoy Photography.*

and a neighbor joined them with a similar number. It was a slow-moving trip, only ten miles a day, allowing the cattle to graze and not arrive in Kansas lean and exhausted. Amanda wrote of their experiences with prairie fires, stampedes and river crossings.

In 1876, the Burkses moved their ranch from near Corpus Christi to Cotulla (north of Laredo). Amanda's husband died a year later, and she managed La Motta Ranch for another fifty years, expanding it to forty-three thousand acres and acquiring another twenty to thirty thousand acres in adjoining Webb County. She was a member of the Old Trail Drivers Association, and a Cotulla school is named for her.

Harriet Cluck is often called the first to go "up the trail." Certainly she was the gutsiest, traveling with three children under the age of seven and pregnant with a fourth. Her husband discouraged her from going, but Harriet—just five feet tall and a hundred pounds—went anyway. "We wanted to be together no matter what happened," she explained.[88] With the money from the cattle sales, the Clucks bought 869 acres at the site of modern-day Cedar Park (west of Round Rock) and established a new ranch.

In 1873, George Cluck had registered a cattle brand in Harriet's name, but it's not likely that she ever drove one of her own herds north.

Harriet's achievements are commemorated in a state historical marker at the Cedar Park cemetery where she's buried and with a statue of her in a Round Rock park that celebrates the Chisholm Trail.

FIRST WOMAN TO RIDE THE CHISHOLM TRAIL WITH HER OWN BRANDED HERD: MARGARET HEFFERNAN DUNBAR HARDY BORLAND (1824–1873)/ELIZABETH ELLEN "LIZZIE" JOHNSON WILLIAMS (1840–1924)

Like the last entry, this one can be tough to call. People often give the title to Lizzie, but history seems to be on Margaret's side.

Margaret Borland was only five years old when she arrived in Texas in 1829 as one of the first Irish colonists. Her family settled in San Patricio (northwest of Corpus Christi), but her father was killed in 1836 by Indians, and, soon after, the family fled the oncoming Mexican army in the "Runaway Scrape."

Margaret married her first husband when she was nineteen; he died in a gunfight in Victoria. Her second husband died of cholera and her third—a rancher near Victoria—of yellow fever, along with four of their children.

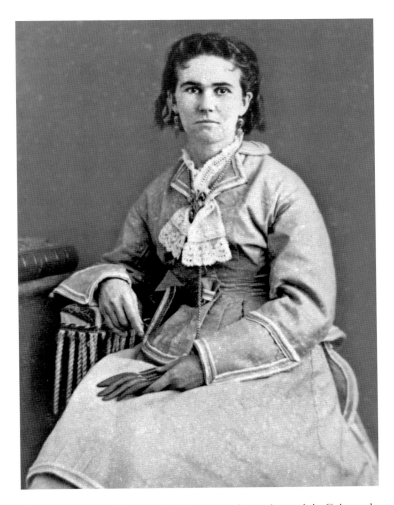

Lizzie Johnson and Hezekiah Williams owned a cattle ranch in Cuba and enjoyed traveling to St. Louis and New York. *Photo 75-539, University of Texas–San Antonio Libraries Special Collections.*

With her three remaining children and a grandson, she took over management of the Borland ranch, building the herd up to ten thousand head of cattle.

In the spring of 1873, Margaret, her children (all aged seven or younger) and her grandchild left Victoria with 2,500 cattle, headed for Kansas. But by the time they reached Wichita, Margaret was ill, and she died in mid-July "from the effects of exposure incident to driving a herd of cattle from the Lone Star State."[89] Thomas Sterne, a neighboring rancher back in Texas, brought her body home to Victoria for burial.

141

The courthouse in Lampasas where the first Farmers' Alliance formed in 1875; women were admitted and also held office. *Courtesy of Dreanna Belden and University of North Texas Libraries.*

Lizzie Johnson Williams was of a completely different character. Well educated and possessing a sharp business sense, Lizzie succeeded at everything: teaching, writing fiction for *Frank Leslie's Illustrated Weekly*, bookkeeping for area cattlemen and investing in real estate. With her profits, she began building her own herd and registered her brand in 1871.

In 1879, Lizzie married cattleman Hezekiah Williams—but with a prenuptial agreement that kept her property completely separate. This was highly unusual for the time; married women in Texas would not be given such rights for another thirty years. (See entry on Hortense Ward.) Hezekiah was not the businessman Lizzie was, and she was forever bailing him out of debt.

The couple usually trailed their herds together for safety, and "it is believed that she did not go up the trail more than two or three times."[90] There is also little evidence that she made the trek before they married.

Lizzie and Hezekiah lived the high life, but all that changed when he died in 1914. She became so reclusive and miserly that most of Austin was startled to find, after she died, that her estate was valued at nearly $1 million in today's money.

ONLY WOMAN ON THE JA RANCH/SAVIOR OF THE SOUTHERN BUFFALO HERD: MARY ANN "MOLLY" DYER GOODNIGHT (1839–1926)

Her tombstone says it best: "One who spent her whole life in the service of others." Everyone from cowhands to school kids to buffalo drew her interest and her energy.

Mary Ann Dyer was born in Tennessee and came to Texas in 1854. When both parents died within a short period, "Molly" was left to raise her five

This bronze statue at the Charles Goodnight home commemorates Molly's role in saving a remnant of the Southern Plains buffalo herd. *William R. McLeRoy.*

brothers. After the Civil War, they moved to Weatherford, where she taught school and soon met cattleman Charles Goodnight, already famous as one of the pioneers of the Goodnight-Loving Trail. They courted for several years before marrying in 1870.

The newlyweds and her brothers moved to Goodnight's ranch in Pueblo, Colorado. But the aftermath of the financial panic of 1873 wiped Charles out, and they returned to Texas—not to a town but to Palo Duro Canyon, the second largest in the country. Ten miles wide, one hundred miles long and 1,500 feet deep, its basin was prime cattle country. Charles partnered with a rich Irishman, John Adair, to build and operate the JA Ranch there.[91]

The Goodnights first lived in a dugout and, later, a small log cabin in the canyon. Their nearest neighbors were seventy-five miles away, and it was several years before another woman moved into the region. She and Molly were glad to see each other once or twice a year. Molly helped with the ranch, took care of the cow hands and, out of loneliness, made pets of three chickens given to her.

This was also the time of expanding transcontinental railroads and hunters slaughtering buffalo for their hides, meat and horn, which could now be easily transported to markets. By 1878, three and a half million buffalo had been killed; by 1885, barely a thousand remained. Hunters didn't bother with calves, which were too small to be worth anything. Molly wrote of hearing the orphaned calves on the prairies above the canyon, bawling for their mothers and dying quickly. She persuaded Charles to capture several to see if they could be bottle-fed.

Molly's first two calves eventually blossomed into a herd of 250, which "became one of the five foundation herds…from which the majority of surviving buffalo have developed."[92] When the herd was donated to Texas Parks and Wildlife in 1996, testing revealed that some were purebred descendants of the original Southern Plains stock. They were moved to Caprock Canyons State Park and designated Texas's official herd in 2011.[93]

Oldest Women's Sports Association and the Only One Governed Entirely by Women: Women's Professional Rodeo Association (1948)

Women were an integral part of rodeo circuits in the early twentieth century. During both world wars, they also ran family ranches while the men were in the military. But after the second war, ranch women, as in so many other

Margaret Owens
First GRA President
&
World Champion Barrel Racer

Margaret Owens, the first president of the Girls Rodeo Association, now the Women's Professional Rodeo Association. *Courtesy of the Women's Professional Rodeo Association.*

industries, found themselves pushed out, particularly when it came to earning equal money in rodeos. Suddenly they were ornaments, not competitors in timed events.

In 1948, thirty-eight women gathered in San Angelo to discuss an idea that had first surfaced at a very successful all-girl rodeo in Amarillo the previous year. The men had an association. Why couldn't the women have one, too? They could organize their own contests and rules, lobby to be included in Rodeo Cowboy Association (RCA) events and work to raise both standards and prize money for women's events.

Ozona cowgirl Margaret Owens (Montgomery) was elected first president of the new Girls Rodeo Association (GRA)—today the oldest professional sports organization for women in the United States—and also won the first championship in 1948. By 1955, the GRA had negotiated an agreement that all women's events at RCA (now the Professional Rodeo Cowboys Association) had to be sanctioned by them.

Today, the organization is the Women's Professional Rodeo Association (WPRA) and has grown so large that there are twelve regions, or circuits, encompassing the entire United States. Barrel racing is the signature event; thanks to WPRA, it's become a standard at most rodeos.

In 1950, the headquarters relocated to The Stockyards in Fort Worth. It later moved to Oklahoma and is now in Colorado Springs. You can watch many WPRA events on RFD-TV.

ONLY FEMALE JOCKEY TO WIN THE ALL AMERICAN FUTURITY/ALL-TIME LEADING FEMALE JOCKEY: TAMI PURCELL-BURKLAND (1959–)

Growing up in Dripping Springs near Austin, Tami Purcell wanted to be a fireman like her grandfather. Fortunately for horse racing, she changed her mind.

Female jockeys were unheard of before 1969, when one entered a race but lost and a second woman won in a different race. Tami began her career just twelve years later, and discrimination against women was still very prevalent. She moved to California and hung around the racetracks, hoping to learn from legends such as Willie Shoemaker and offering to exercise any horse there. She quickly earned a reputation for handling the most fractious horses and won her first race on one.

Tami Purcell-Burkland at her induction into the Texas Horse Racing Hall of Fame in 2013. *Courtesy of Texas Horse Racing Museum and Hall of Fame, Selma, Texas.*

She's ridden both Thoroughbreds and Quarter Horses but prefers the latter, and that's where she's really made her mark as the breed's most successful female jockey, winning the Champion of Champions (1996), the Texas Classic Futurity (1996) and the All American Futurity (1997)—and that was after she'd broken her back in a 1992 wreck. She's still the only woman to have captured the Futurity, the richest Quarter Horse race in the country.

After winning every major race and breaking pretty much every bone she had, Tami retired in 2000. She'd ridden in almost 9,500 races and won 2,143 of them, with purses totaling more than $12 million. So what was left for her to do? Barrel-racing in rodeos.

She joined the Women's Professional Rodeo Association (see entry) and was a two-time Wrangler Nationals Rodeo Qualifier. She retired from that sport in 2007 and now trains barrel-racing horses at her ranch near Dripping Springs; she also spent several years offering clinics in barrel-racing. Tami came out of retirement in 2014 to ride in several races benefiting cancer research, winning the Mother's Day Stakes in Louisiana and placing second in the Lady Legends for the Cure race at Pimlico.

ONLY MUSEUM IN THE WORLD DEDICATED TO COWGIRLS: NATIONAL COWGIRL MUSEUM AND HALL OF FAME (1975)

In 1975, folks in Hereford (southwest of Amarillo) decided they needed to get some excitement going about their area. An all-girls rodeo that summer was the first shot in the arm, and the second, more long-term solution was establishing a National Cowgirl Hall of Fame and Western Heritage Center. The first acquisition for that was the archive of the Girls Rodeo Association (see entry).

The hall began in the basement of the Deaf Smith County Public Library but grew so fast that it soon moved to a six-thousand-square-foot former residence, large enough to house the artifacts, photographs and art that poured in from donors. From the beginning, its most central purpose has been to honor the women who'd distinguished themselves in rodeo competition and those who exemplified the pioneer spirit of the American West.

But within a decade, that facility, too, was full, and director Margaret Formby searched for a new site. Thirty-five cities in six states made bids, but Fort Worth—Cowtown—won. The new museum and hall of fame would be located in the city's world-renowned Cultural District and adjacent to

Cowgirls race across the western plains in this mural by Richard Haas at the National Cowgirl Museum and Hall of Fame in Fort Worth. *Ann McLeRoy Photography.*

Entrance to the Art Deco–style National Cowgirl Museum and Hall of Fame. *Ann McLeRoy Photography.*

the Will Rogers Memorial Center, home of the oldest livestock show in the United States and the first indoor rodeo in the world. A lot of women have competed there over the years.

The new, thirty-three-thousand-square-foot Art Deco building opened on June 9, 2002. The exterior features *trompe l'oeil* murals by Richard Haas and bas-reliefs by Janice Hart Melito, and sculptures by Mehl Lawson and

Glenna Goodacre decorate the entry area. Inside, the columned rotunda features twelve glass-tile murals designed by Rufus Seder, which constantly change. Galleries on two floors tell the stories of "women who stepped up, not aside."[94] The museum houses more than five thousand artifacts and five thousand images, one of the most extensive collections on western women.

Every October, the hall of fame inducts a new class of honorees. New in 2014 was Dr. May Owen, who joined Molly Goodnight, Sandra Day O'Connor and Hortense Sparks Ward—all featured in this book.

Chapter 13

SOCIAL AND RELIGIOUS

FIRST OFFICIAL JEWISH SERVICE IN TEXAS: ROSANNA DYER OSTERMAN (1809–1866)

Rosanna Osterman was a force in Galveston's early Jewish community. Born in Germany, she came to Baltimore with her parents as a small child and there married Dutch-born Joseph Osterman. He left her with family while he sailed to Galveston to start a business; she joined him later. Within four or five years, the couple had earned enough in the bustling port city to retire.

In the 1840s, Galveston's Jewish community was quite small, unable to afford a synagogue or separate cemetery. Local lore says that Rosanna was aghast when a Mr. Abrahams died of yellow fever in 1839 and had to be buried in the Protestant graveyard. A Jewish cemetery was not established until 1852, when Rosanna and her family brought Rabbi M.N. Nathan from New Orleans to consecrate the site, thought to be the first Jewish service in Texas. But not for another four years would they begin to hold regular services, meeting in the home of her brother, Isadore Dyer.

As a widow, Rosanna opened her home during Galveston's several yellow fever epidemics and again during the Civil War, when she nursed both Confederate and Union soldiers. She is credited with sending regular intelligence reports to the Confederates, allowing them to retake the city in 1863.

Rosanna died in 1866 in a steamboat explosion, leaving an estate of more than $200,000, an enormous sum at that time. She left most of it to charity, allowing Galveston Jews to at last build Temple B'nai Israel in 1871.

Oldest Woman's Club in Texas: The Victoria Literary Society/Bronte Club and Viola Case (1821–1894)

And from eleven books in a dry goods box, there grew a library.

Viola H. Shive Case, a Virginian, was educated in Baltimore. She came to Victoria in 1848 with her first husband, Rev. John R. Shive, to open a Presbyterian school for girls, the Victoria Female Academy. Advertisements state that the school was run by John R. Shive "and Lady," a rather demeaning reference to Viola.

Shive died in the 1853 yellow fever epidemic, leaving his wife with an eighteen-month-old child. (Two of their children were already dead, and the baby died later, in 1874.) Viola had no choice but to keep the school open to support herself and her son. In 1855, two important events in her life happened: she married a new teacher, Rev. Joel T. Case, and started the Victoria Literary Club to excite her pupils about literature. Viola kept eleven books in a box under her bed and pulled them out once a week to share with the girls. She didn't know it at the time, but that was the beginning of the Victoria Public Library.

She and Case operated the school until the Civil War, when fear of Victoria being invaded by Union forces forced them to move to Clinton, some miles inland near modern Cuero. In June 1866, they returned to Victoria and reopened the academy. Former pupils recalled after Viola's death that she was "a woman of great influence in…the dismal years of upheaval following the collapse of the southern confederacy."[95]

Her literary club might have collapsed, too, had not a group of New York reporters antagonized every woman in America in 1868 by refusing to invite any females to a reception for English writer Charles Dickens. The Sorosis Club formed soon after and called for America's women to establish the Association for the Advancement of Women. Viola is thought to have attended that formative meeting and been inspired by it. Her literary society was rejuvenated as the Bronte Club (so named for authoress Charlotte Bronte) and soon reached beyond the school to embrace Victoria's married women, too.

Viola's life changed again after Joel Case died; the building used by the school was sold, and Viola opened Mrs. Case's Select School in her home. By now sixty years old, she tried to sell the school to the Presbyterian Church so she could retire. But the church declined, and the school remained under her supervision until her death in 1894. Attendance at her funeral was unusually large, as many former pupils came to pay their respects. Two years later, alumnae erected a graveside monument in her honor.

Over the decades that followed, the Bronte Club grew more involved in Victoria's growth, campaigning for an artesian water system, helping form a Civic Improvement League and bringing Eleanor Roosevelt to speak. But its main thrust was always Viola's library. Today, the Bronte Club not only still exists—the oldest woman's club in Texas—but is also a mainstay of what is now the Victoria Public Library.

First American Mother House of the Sisters of Divine Providence: Castroville (1868–96)

Ringed on three sides by the Medina River and backing up to a low ridge of hills, Castroville was settled in 1844 by Catholic Alsatians brought to Texas by Henri Castro. It was patterned after French villages of the Alsace-Lorraine region, with lots surrounded by farming plots and houses of stone and timber.

By the time two Sisters of Divine Providence (SDP) arrived there in 1868, Castroville had survived Indian attacks and drought and was one of the larger towns in Texas. Sisters Alfonse Boegler and St. Andrew Feltin, superior of the new mission, came from the mother house in Lorraine, France, at the invitation of Bishop Claude Debois to organize girls' schools in the area.[96] The SDP—named for their belief that Divine Providence would guide and sustain them—was a teaching order founded in France in 1762 by the Blessed John Martin Moye.

The Sisters opened their first schools in Austin and Corpus Christi before settling permanently in Castroville. As more followed, they constructed several large dormitory, convent and school buildings, comprising the order's first mother house in this country. German-born artist Rudolph Mueller painted a panoramic view of the complex and the surrounding area in the late nineteenth century.

But in 1888, the railroad bypassed Castroville, and in 1896, the Sisters moved the mother house to the larger San Antonio, some thirty miles away,

Rudolph Mueller, a Castroville resident, painted this view of the Sisters of Divine Providence mother house sometime before 1896. *Courtesy of the Witte Museum, San Antonio.*

where they established what is now Our Lady of the Lake University. But the original Castroville structures still survive; today, most are part of the order's Moye Retreat Center.

First Female Member and Last Surviving Member of the Texas Veterans Association/ First Woman to Have Her Portrait Hung in the Texas Senate: Rebecca Gilleland Fisher (1831–1926)

She first became famous as a child. And it wasn't the kind of fame that most of us would want.

Rebecca Gilleland was born in Philadelphia; her family moved to Texas in 1837 and settled in Refugio County, between Victoria and Corpus Christi. When Rebecca was nine, Comanches attacked their home, killed her parents and captured her and her brother. Rescued by a detachment of Texas soldiers, the children were taken to Galveston to live with an aunt. Rebecca later wrote an account of her captivity, *Captured by Comanches*, but never discovered where her parents were buried.[97]

She attended the women's division of Rutersville College near La Grange and, in 1848, married Rev. Orceneth Fisher. The couple moved to the West

Coast (the Pacific Conference of the Methodist Church) and did not return to Texas until 1871, settling in Austin in a house across from the Capitol.

Though she did not meet the qualifications, her early and painful experiences in Texas led to her being elected as the first female member of the Texas Veterans Association, organized in 1873. Across her membership certificate was written that Rebecca Fisher was "elected in her own right equal with men."[98] She also qualified for the Daughters of the Republic of Texas (organized in 1891) and served as president for nearly two decades. With Clara Driscoll and other DRT members, Rebecca fought to preserve the Alamo in San Antonio.[99]

Rebecca Fisher was captured by Comanches at the age of seven. *Courtesy of Fort Worth Public Library, Local History and Genealogy Division.*

She regularly contributed articles to magazines and newspapers in these later years and belonged to the Texas Woman's Press Association. She was the only female orator at the unveiling of the Sam Houston monument in Huntsville, and her portrait was hung in the Texas Senate Chamber, the first woman to be so honored. When she died in 1926, her body also laid in state there, her portrait draped in black.

FIRST WOMAN'S CHRISTIAN TEMPERANCE UNION (WCTU) CHAPTER IN TEXAS/FIRST SOUTHERN WCTU TO ENDORSE SUFFRAGE: PARIS (1881)/TEXAS (1888)

•

Frances Willard, then national president of the Woman's Christian Temperance Union (WCTU), came to Texas to establish local chapters, or

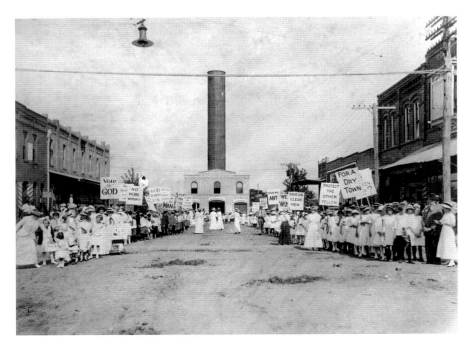

Women rally in Lufkin (1915), demanding "clean men" and "no more whisky." *Courtesy of the Museum of East Texas in Lufkin.*

unions, as part of her three trips to the southern United States between 1881 and 1883. (WCTU advocated total abstinence from alcohol, even down to the wine used for Communion.) In May 1881, Frances organized the state's first WCTU chapter in Paris, on the Red River, at the home of a noted male prohibitionist, but it was largely inactive until Jenny Bland Beauchamp became state president in 1883. Jenny traveled over five thousand miles, crisscrossing Texas to organize and galvanize local groups such as Paris and to speak on temperance.

One of the tenets of the northern WCTU was women's suffrage, in the belief that the sooner women had the vote, the sooner they could vote prohibition in and shut down the saloons and liquor stores. But in 1881 Texas, not many were yet thinking along those lines. Some churches wouldn't even allow Frances Willard to speak on temperance in their buildings, though it was a movement their officials supported. (Plus, some of them were still riled about that "no communion wine" edict.) •

And by appearing in public, they believed, Frances Willard had "stepped out of the sphere in which her Creator placed her and taken upon herself

the duties belonging solely to a man," as the editor of the *Denison Democrat* expressed it. "When Christ wanted apostles, he chose men, not women."[100]

Still, women's suffrage was central to WCTU's mission. In 1888, the Texas organization became the first in the South to officially endorse the concept, though the action caused many conservative members to leave. Not until 1919—just after women finally got the vote—did Texas voters approve prohibition.

OLDEST ADOPTION AGENCY IN TEXAS: THE TEXAS CHILDREN'S HOME AND AID SOCIETY/EDNA GLADNEY HOME (1887)

Around 1887, a loose confederation of Fort Worth women's groups, led by the Woman's Christian Temperance Union, began an effort to rescue the city's poor, abandoned and dependent children. That devolved into the Benevolent Home, an orphanage that existed under varying names until the late 1970s. In 1891, the Rev. I.Z.T. Morris (1847–1914) arrived in Fort Worth and soon joined their efforts.[101]

Representatives of the National Children's Home and Aid Society in Chicago came to Fort Worth in 1896 to organize a state society. These were operated on the principle of not warehousing children into orphanages but placing them with families and in homes as soon as possible. Rev. Morris was named superintendent and spent the rest of his life—more than two decades altogether—rescuing children in Texas and the Southwest and "creating bright futures" for them.

After his death, some five or six superintendents, including his wife, Belle Morris, tried to cope with both changing and lean times in the emerging profession of social work. In 1927, the Texas Children's Home board gambled all on a short, dark-haired dynamo named Edna Browning Kahly Gladney (1886–1961). Born in Milwaukee, Edna Kahly came to Fort Worth in 1904 and, in 1906, married flour miller Sam Gladney. While living in Wolfe City (northeast of Dallas) and, later, Sherman (on the Red River), Edna, who was passionately interested in child welfare, became involved with the organization as a volunteer.

In 1921, Sam and Edna lost their home and business in market reversals and returned to Fort Worth, where she spent more time helping at the Children's Home. When the board came to her in 1927 asking her help in clearing its debt, she agreed to stay for six months.

Texas adoption activist Edna Gladney challenged the law and forever changed birth certificates of adopted children. *Courtesy of the Gladney Center for Adoption.*

She was still there thirty-three years later.

Edna not only cleared the debt but also found the Home's first permanent structure, a rambling old house on El Paso Street where she cared for the ever-increasing numbers of babies and children needing families. In the 1930s, she threw herself into a campaign to change Texas birth certificates, which clearly indicated if a person was illegitimate. Why? Because she was illegitimate herself. She and other social workers were eventually successful,

and Texas became the first state in the Southwest to remove that ugly blot from its official records.

Edna's next effort was directed toward the birth mothers whose children found their way to her door, and she did much to reduce the stigma of both the unwed mother and her out-of-wedlock child. Edna's belief was quite simple: "There are no illegitimate children, only illegitimate parents!"

In 1941, Metro Goldwyn Mayer Studios released a film about her life, *Blossoms in the Dust*, starring Greer Garson and Walter Pidgeon. In coming years, Edna would be featured in many magazines and television shows, as well as another movie.

The Texas Children's Home was renamed in Edna's honor in 1950. Today, it is the Gladney Center for Adoption and is still located in Fort Worth.[102]

FIRST STATEWIDE SUFFRAGE ORGANIZATION IN THE UNITED STATES: TEXAS

The history of women's suffrage in Texas is a jumbled mess of organizations that came and went, dozens of bills that were introduced but never passed and the general inertia of changing a system that had been in place for centuries—all beginning in the Reconstruction period after the Civil War.

The first bill to grant suffrage to Texas women was introduced in 1868 at the Constitutional Convention. It failed, as did so many others in the following years. But in 1893, an organization emerged to fight for such a bill, the Texas Equal Rights Association (TERA), founded by Rebecca Henry Hayes, a professional journalist from Galveston. TERA vowed to "advance the industrial, educational, and equal rights of women, and to secure suffrage to them by appropriate State and National legislation."[103] It dissolved in 1896 but led in 1903 to the Texas Woman Suffrage Association, which remained dormant from 1905 until 1913.

Eleanor Brackenridge, though in her seventies, was then elected president, and Minnie Fisher Cunningham led the final push when she took the reins in 1915. The renamed Texas Equal Suffrage Association was now an affiliate of a national organization and the only one operating on a statewide level for women's enfranchisement.

Then an opportunity to push anti-suffrage governor James Ferguson out of office on impeachment charges led the way for a pro-suffrage successor, William P. Hobby. In 1918, Texas women finally won the right to vote in

Texas suffragists are at the front of the line in this 1913 march in Washington, D.C. *Photo LC-USZ62-8312, courtesy of Library of Congress Prints and Photographs Division.*

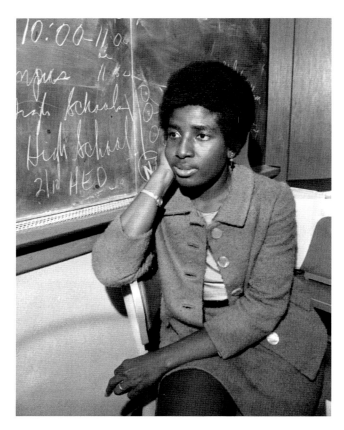

Dr. Gloria Scott of Houston, the first black president of the Girl Scouts of America, had a goal "to integrate cultures rather than races." *Courtesy of* Houston Post *Collection (RGD0006N-1225-F001), Houston Public Library, HMRC.*

primary elections, and almost 400,000 women immediately registered. But when the legislature convened to consider Hobby's recommendation that women be granted full suffrage in 1919—which required a popular vote since it was a constitutional amendment—matters took a Texas-size and very convoluted twist. Hobby also wanted to deprive foreign nationals of the vote until they became citizens, so the women and the aliens wound up in the same resolution. You can guess what happened. The aliens wanted to keep their enfranchisement, so they voted against it. And the women couldn't vote. The resolution failed.

Fortunately, Congress proposed the Nineteenth Amendment to give women the vote in March 1919. In June 1919, both houses of the Texas Legislature ratified it, making Texas the ninth state and the first in the South to approve votes for women.

OLDEST TEXAS APPLICANT TO BECOME A NATURALIZED CITIZEN: RUPERTA URRESTA HERNANDEZ (1892–1999)

In 1915, while Texas women were fighting to win the right to vote, Hilario and Ruperta Urresta Hernandez were fleeing the Mexican Revolution's violence. Eighty-four years later, Ruperta would become the oldest Texas applicant to be declared a naturalized citizen. Why did she wait until she was 107? Because she wanted to vote before she died.

Ruperta was born in 1892 in Hacienda Mamulique in northern Nuevo Leon, near the Rio Grande. She and Hilario crossed the border at Laredo with their three small children and eventually settled in Converse, Texas, on the northeast side of San Antonio, where they grew cotton and corn and raised eleven children on their farm. Hilario died in 1963, but Ruperta lived there until 1997, when she finally moved into San Antonio with one of her sons.

A federal magistrate came to their home on her 107th birthday to administer the oath to Ruperta, who was wearing a pink-and-white carnation corsage and surrounded by her family. It made the news around the country.

Sadly, Ruperta enjoyed her citizenship less than a month before passing away.

NOTES

CHAPTER 1

1. An escadrille is a small European aerial unit, usually consisting of six airplanes.
2. *Cleveland Plain Dealer*, September 5, 1916.
3. Elaine Derouen, "Above the Cotton Fields: The Bessie Coleman Story," *Code One*, October 1990, 19.
4. One photograph shows her hanging jauntily from the wing of a biplane by only one hand.

CHAPTER 2

5. *(San Antonio) Alamo Star*, October 16, 1854.
6. *(Washington, TX) Texas Ranger*, September 15, 1855.
7. Ibid.
8. Ibid., September 22, 1855.
9. *Houston Daily Post*, November 30, 1896.
10. *Milwaukee Journal*, July 10, 1943.
11. Martin reprised "My Heart Belongs to Daddy" for the 1946 Cole Porter biopic *Night and Day*, starring Cary Grant.
12. Brochure on the Margo Jones Award in the files of the Woman's Collection at Texas Woman's University.

CHAPTER 3

13. Martha Washington appeared on the U.S. one-dollar silver certificates of 1886, 1891 and 1896. She and Pocahontas were featured in the engraving of "Introduction of the Old World to the New," which was used on several paper denominations in the 1870s. Susan B. Anthony, Helen Keller and Sacajawea have appeared on several circulating coins. They are the only women to have been so honored.

14. Advertisement in *The Mentor* of June 1894, page 256.

15. Caplan, *Petticoats and Pinstripes*.

16. *Texas Bankers Record*, 7 (June 1918): 87–88.

17. Ibid., 68.

18. *Texas Department of Agriculture* 61–64: 93.

CHAPTER 4

19. When the Alamo fell to Mexican forces on March 6, 1836, Sam Houston, general of the Texian forces, fell back to the east, carrying inhabitants with him out of harm's way. Mexican general Santa Anna immediately pursued, and Texians in his path fled. It was a disastrous event dubbed the "Runaway Scrape."

20. Only the columns and front porch of the Women's Department survive today in Independence's Old Baylor Park.

21. In the nineteenth century, "seminary" usually referred to a women's college.

22. Their eldest child died at birth.

23. *Annual Report of the American Missionary Association* 30–39: 58.

24. *The American Missionary* 18: 199.

25. From www.aggiewomen.org.

CHAPTER 5

26. As reported in the *San Antonio Express*, January 10, 1971, U.S. Rep. Henry Gonzalez told students that "Emma Tenayuca stood right here on this stage and whipped our ears in debate."

27. The pecan is both Texas's official state tree and its official health nut. Pecan production had been mechanized before the strike but returned to hand labor during the Depression because labor was much cheaper than machinery.

28. If you'd like the recipe, you can find it in *Grace & Gumption: The Cookbook*, 238–39.

Chapter 6

29. Jackson, *Texas Governors' Wives*, 13, 14.
30. Ibid., 15.
31. Ibid., 17.
32. Frances is said to have crossed the Atlantic Ocean fifteen times, racking up more than sixty thousand sailing miles. Her eldest daughter married an Austrian baron and lived in Salzburg; the middle daughter, Julia, married a Louisiana sugar plantation owner whom she met in France; and the youngest, Martha, died in Germany at age eighteen.
33. Barr, *All the Days of My Life*, 191, 212. Amelia much admired Texas women. In that same book (page 211), she wrote that they were "brave and resourceful, especially when her environment was anxious and dangerous. They were then [1856–65] nearly without exception fine riders and crack shots, and quite able, when the men of the household were away, to manage their ranches or plantations and keep such faithful guard over their families and household, that I never once in ten years, heard of any Indian, or other tragedy occurring."
34. *Richmond Hill Record*, Amelia Barr obituary, March 15, 1919.
35. Noemi Martinez, "Jovita Idar: 'There Are So Many Dead That Sometimes I Can't Remember All Their Names.'" Posted on www.hermanaresist.com/category/jovita-idar, May 30, 2012.
36. Some sources state that the Texas Ranger raid happened at the office of the Idar family newspaper, *La Cronica*. This makes more sense, given that Jovita married in 1917 after the paper closed.

Chapter 7

37. Venereal disease was so prevalent at the time that many recruits didn't pass their physical exams. It was a very serious problem for the U.S. Army, which dealt with similar "pleasure" districts and "camp followers" across the country.
38. In 1952, Waco native Madison Cooper Jr. had a *New York Times* bestseller in his novel *Sironia, Texas*, based loosely on Waco. Many residents thought

his character of madam Lorene Lane was Mollie Adams in disguise. *Sironia* was the longest book published in the United States up to that time, with one million words and 2,119 pages.

39. *El Paso Herald*, May 20, 1902.

40. Unidentified and undated clipping from files in the Woman's Collection at Texas Woman's University. The article is headlined "Bill to Give Married Women More Rights' [*sic*] Framed by Ft. Worth Judge," but it begins by quoting from an article Hortense wrote for the *Houston Chronicle*, the source of the quote.

41. *Houston Post*, April 27, 1913.

42. Gabrielle was also a visiting professor at the University of Texas–Austin School of Law and the Thurgood Marshall School of Law at Texas Southern University.

43. The oldest federal judgeship in Texas today is in Galveston, and the 1861 Customs and Courthouse—now housing the offices of the Galveston Historical Foundation—is the oldest federal civil building in the state.

44. There is a Sandra Day O'Connor High School in Helotes, Texas (a suburb of San Antonio), and Austin High School in El Paso, O'Connor's alma mater, houses the Sandra Day O'Connor Criminal Justice and Public Service Academy.

Chapter 8

45. The full title is *Texas: Observations, Historical, Geographical, and Descriptive, in a Series of Letters Written during a Visit to Austin's Colony, with a View to a Permanent Settlement in That Country in the Autumn of 1831.*

46. Mary's original words and music were lost long ago. In 1936, for the centennial of Texas's independence from Mexico, David W. Guion and John William Rogers rewrote it for a performance.

47. Letter to her cousin Orville Holley dated December 24, 1831. Copy in the Woman's Collection at Texas Woman's University.

48. Letter to her cousin, probably Oliver Holley, dated April 12, 1844.

49. *Dallas Herald*, August 14, 1858.

50. *Belton Independent*, July 17, 1858.

51. Ibid.

52. A.R. McTee, "Mrs. Anna Hardwicke Pennybacker," A.R. McTee Literary Effort, Collection #2-23/958, Texas State Library and Archives Commission.

53. *Daily Ardmorite (OK)*, October 30, 1902.

54. *Palestine (TX) Daily Herald*, March 7, 1906. That year, Mary moved the newspaper's production office to Dallas but maintained the editorial office in Sherman.

55. *Texas Mesquiter*, February 7, 1908, and July 7, 1911.

56. Published in the *Dallas Morning News* in 1935 (no other date available).

CHAPTER 9

57. *UTMB: The University of Texas Medical Branch at Galveston*, 55.

58. *Galveston (TX) Daily News*, May 16, 1897.

59. *UTMB: The University of Texas Medical Branch at Galveston*, 55.

60. John Sealy Hospital's Training School for Nurses opened in 1890 and was the first university-affiliated nursing school in the United States.

61. The first American woman to become a dentist was Dr. Lucy Hobbs Taylor of Iowa and Kansas in 1866. The *Texas Dental Journal* was established in 1883 and is now the longest-running, continuously published dental journal in the country and second in the world behind the *British Dental Journal*.

62. *Dental Register (Cincinatti)* (January 1899): 149.

63. *Church Advocate (Baltimore)*, "Afro American News," October 22, 1892.

64. Because Dr. Mary had cared for World War I soldiers and frequently signed her name as Dr. M.L. Shelman, the second world war brought her many draft notices. When their tone became threatening, she politely informed the draft board that she was a seventy-year-old woman and really wasn't the kind of dentist the military was looking for. Cross Plains is also known as the hometown of Robert E. Howard, author of the *Conan the Barbarian* series.

65. "Materia Medica" is the study of the therapeutic properties of medicines.

66. Burns, *Saving Lives*, 183.

67. Dr. Frances Van Zandt worked at the Mayo Clinic for many years.

68. Silverthorne and Fulgham, *Women Pioneers in Texas Medicine*, 91.

69. Stafford, *May Owen*, 75.

70. Dr. May Owen was inducted into the National Cowgirl Museum Hall of Fame in October 2014.

71. U.S. National Library of Medicine, "Dr. Benjy Frances Brooks," www.nlm.nih.gov/changingthefaceofmedicine/physicians/biography_44.html.

Chapter 10

72. In her book (page 369), Emma wrote, "Over miles of shattered forest and torn earth the dead lie, sometimes in *heaps* and *winnows*…You can distinctly hear, over the whole field, the hum and hissing of decomposition."
73. *Houston Daily Post,* June 2, 1901. Emma was originally buried in Morgan's Point Cemetery in La Porte.
74. *Dallas Morning News*, October 14, 1945.
75. Until 2007, it was thought that Mary was the very first Silver Star recipient. In World War I, nurses could be awarded a Citation Star. The first to be eligible for the honor was U.S. Army nurse Linnie Leckrone of Boulder, Colorado, who served in France; however, she was discharged before the honor could be given. In 1932, the U.S. army allowed Citation Stars to be exchanged for Silver Stars. As of 2011, three World War I nurses in France, four—including Mary Roberts—in World War II and one in Iraq are the only female recipients of the Citation/Silver Star.
76. Posted on www.hamelia.tripod.com/cochran.html.
77. *Dallas Morning News*, October 8, 1940.
78. Debbie Mauldin Cottrell, "Kathryn Cochran Cravens," *Handbook of Texas, Vol. 2.*

Chapter 11

79. Crockett's body is thought to have been burned after the Battle of the Alamo.
80. Samuel E. Asbury, "Maud J. Young: Biographical Data," in Samuel E. Asbury Collection (#2-23/797), Texas State Library and Archives Commission, 2.
81. Young, *Familiar Lessons*, 98.
82. Ibid., 66–67.
83. *Galveston Daily News,* July 21, 1924.
84. *Taylor (TX) Daily Press,* January 28, 1924.

Chapter 12

85. During this period, the Nueces River was the boundary between Mexico and the province of "Texas." After the Mexican-American War, in 1848, the Rio Grande was made the boundary.

86. If you believe John Wayne, Texas's cattle industry was born in the desert. But it actually began in the Lower Rio Grande Valley because of people like Rosa Maria Hinojosa de Balli, who brought their herds over from Mexico to graze in the lush grasslands.

87. On a map, the cattle trail out of Texas looks like an upside-down parrot tulip. From Red River Station (Montague County), it went directly north across the Indian Territory (Oklahoma) to Abilene and Wichita. But within Texas, it rippled out to several destinations, including Fort Chadbourne to the west, Corpus Christi and Brownsville to the south, Victoria, Cameron, Dallas and Fort Worth, with all these paths coming together at the Red River.

88. Karen R. Thompson, "Hattie Cluck: The First White Woman on the Cattle Trail." *Community Impact (Austin)*, posted on August 1, 2007.

89. *Wichita (KS) Eagle*, July 31, 1873.

90. Shelton, "Lizzie E. Johnson," 356.

91. The JA Ranch is still in operation.

92. Texas House of Representatives Resolution No. 86.

93. The Goodnights' last home, near Claude, has been restored and is open for tours. There is also an adjacent museum with information on their lives and contributions to Panhandle history.

94. See the museum's website at www.cowgirl.net.

CHAPTER 13

95. *Dallas Morning News*, November 27, 1899.

96. A mother house can be the original convent of a religious community or the convent in which the superior of such a community lives. In the case of Castroville, both meanings applied. (*Merriam-Webster's Collegiate Dictionary*, tenth edition.)

97. *The Bohemian (1904 Souvenir Edition)*, 7.

98. Original membership card in Rebecca Fisher Collection of Austin History Center (Box 1, Folder 6).

99. The Texas Veterans Association was open to surviving members of Stephen F. Austin's Old Three Hundred (the first Anglo colony in Texas) and to veterans from 1820 to 1845. Daughters of the Republic of Texas were women directly descended from those who established the Republic of Texas. When the TVA dissolved in 1907, the DRT took over much of its work. (*Handbook of Texas*)

100. Ivy, "The Lone Star State Surrenders," 56.
101. For several decades, the Benevolent Home and the Texas Children's Home worked together on some projects.
102. For more information, see McLeRoy, *Texas Adoption Activist Edna Gladney: A Life and Legacy of Love*, available from The History Press.
103. Austin History Center, "Austin Treasures: Online Exhibits from the Austin History Center: Jane McCallum and the Suffrage Movement," www.austinlibrary.com/ahc/suffrage/early.html.

BIBLIOGRAPHY

ARCHIVES AND MANUSCRIPTS

Austin History Center.
Dolph Briscoe Center for American History, University of Texas at Austin.
Fort Worth Public Library, Genealogy and Local History.
Sindescue Museum of Dentistry, University of Michigan.
Sivells, Wanda Kellar. "Dr. Mary: An Early Texas Dentist." Woman's
 Collection, Texas Woman's University.
Texas State Library and Archives Commission.
Texas Woman's University, Lou Halsell Rodenberger Woman's Collection.
University of Texas–Arlington, Special Collections.
Woman's Club of Fort Worth Archives and Library.

ARTICLES

Acosta, Belinda. "Have You Ever Been to Carrascolendas?" http://www.
 austinchronicle.com/screens/2003-07-04/166689/.
African American Registry. "Azie Taylor Morton, Energy and Purpose."
 http://www.aaregistry.org/historic_events/view/azie-taylor-morton-
 energy-and-purpose.
Alexander, Susan. "Rebecca Stuart Red: Fulfilling Educational Rights of
 Texas's Young Women." *Texas Historian* 48, no. 1 (September 1987).

Allen, H.D. "The Paper Money of the Confederate States." *The Numismatist*, January 1918.

Americans Who Tell the Truth. "Emma Tenayuca." www.americanswhotellthetruth. org/portraits/emma-tenayuca.

Balli, Cecilia. "The True Meaning of the Tejano Movement." *Texas Monthly*. www.texasmonthly.com/story/true-meaning-tejano-movement.

Baylor Health Care System. "Triumph on the Battlefield." http://mbasic. facebook.com/notes/baylor-health-care-system/triumph-on-the-battlefield.

Baylor University. "Mother Neff State Park: A Texas Original." http:// blogs.baylor.edu/texascollection/2013/07/10/mother-neff-state-park-a-texas-original/.

Bills, E.R. "Great Debate." *Fort Worth, Texas*, February 2014.

BlackPast.org. "Morton, Azie Taylor (1936–2003)." http://www.blackpast. org/aah/morton-azie-taylor-1936-2003.

Brans, Jo. "Household Words." *D Magazine*, February 1979.

Brody, Seymour. "Jewish Heroes and Heroines of America: Rosanna Dyer Osterman: A Civil War Nurse and Philanthropist." http://www.fau.edu/ library/brody33a.htm.

Brooklyn Museum. "Jovita Idar." http://www.brooklynmuseum.org/ eascfa/dinner_party/heritage_floor/jovita_idar.php.

Buchholz, Brad. "The First Family." *Austin American-Statesman*, July 14, 2008.

Burks, Amanda Nite. "A Woman Drives Cattle from Texas." http:// buffalocommons.org/site/en/stories/125-a-woman-drives-cattle-from-texas.

Burnett, John. "Lydia Mendoza: The First Lady of Tejano." http://www. npr.org/templates/story/story.php?storyId=127033025.

Burton, Harley True. "A History of the JA Ranch." *Southwestern Historical Quarterly* 32 (July 1928–April 1929).

BusinessWeek. "Gabrielle McDonald: Executive Profile & Biography." http://investing.businessweek.com/research/stocks/people/person. asp?personId=588720&ticker=FCX.

Campbell, Suzanne. "Rosanna Dyer Osterman, 1809–1866." Jewish Women's Archives. http://jwa.org/encyclopedia/article/osterman-rosanna-dyer.

The Cattleman. "Mrs. Elizabeth Crockett." November 1952.

Cattarulla, Kay. "'I'm Doing It, Darling!': Dallas, Margo Jones, and *Inherit the Wind*." *Legacies: A History Journal for Dallas and North Central Texas* (Fall 2004).

Cheney, Louise. "Davy Crockett's Widow." *Texas Parade*, April 1961.

"The Color Question in a Dental College." *American Journal of Dental Science* 26 (1893).

Daley, Bill. "Lucille B. Smith Blazed Trails as Black Culinary Entrepreneur." *Chicago Tribune*, July 12, 2014.

Davis, Margaret H. "Harlots and Hymnals: An Historic Confrontation of Vice and Virtue in Waco, Texas." *Mid-South Folklore* (Winter 1976).

Derouen, Elaine. "Above the Cotton Fields: The Bessie Coleman Story." *Code One*, October 1990.

Dillon, Margie. "A Texas Treasure—An Interview with Ebby Halliday." *Mobility*, November 2010.

Dunn, Si. "Why Sissy Farenthold Is Not in Political Exile." *Texas Woman*, March 1979.

Fort Worth Museum of Science and History. "About Noble Planetarium." http://www.fortworthmuseum.org/noble-planetarium-about.

———. "Charlie Mary Noble." http://www.fortworthmuseum.org/charlie-mary-noble.

Goetting, Mrs. Charles. "Tribute to Olga Kohlberg." http://www.elpasohistory.com/hoh-article-with-slide-show-included/2-uncategorised/95.

Haag, Flora. "Women in Dentistry." *Dental Cosmos* 53 (1911).

Hand, Randall. "RIP Leslie Hope Jarmon 1952–2009, Second Life Innovator." http://www.vizworld.com/2009/12/rip-leslie-hope-jarmon-1952-2009-life-innovator/#sthash.ZBBAi6c3.dpbs.

Herring, Joe. "Florence Thornton Butt—A Woman of Substance." *Lifestyle of Comanche Trace and the Texas Hill Country* (August/September 2011).

History Depot. "Feisty Female (or Not): The Legend of Hattie Cluck, Pioneer Woman." http://history depot.wordpress.com/2014/06/27/feisty-female-or-not-the-legend-of-hattie-cluck.

Hoerneman, Christie. "A Female Soldier in the Civil War: Emma E. Edmonds." http://www.librarypoint.org/emma_edmonds_female_soldier.

Hornaday, W.D. "Mrs. Pennybacker." Texas State Archives, file 1975/070.

Howard, Lillie. "Estelle Massey Osborne: Fighting Racial Discrimination." *Hudson Valley Press*, March 20, 2013. http://www.hvpress.net/news/180/ARTICLE/12212/2013-03-20.html.

Ivy, James D. "'The Lone Star State Surrenders to a Lone Woman': Frances Willard's Forgotten 1882 Texas Temperance Tour." *Southwestern Historical Quarterly* 102 (July 1998–April 1999).

Jewish-American History Foundation. "Jews in the Wild West: Rosanna Dyer Osterman." http://www.jewish-history.com/wildwest/rosanna.html.

Kirkpatrick, Linda. "Mary Ann Goodnight and the Texas State Bison Herd." http://www.texasescapes.com/LindaKirkpatrick/Mary-Ann-Goodnight-and-the-Texas-State-Bison-Herd.htm.

Kline, Donna S. "Virtuoso: The Olga Samaroff Story." Musical America Worldwide, October 29, 2010. http://www.musicalamerica.com.

Latinopia.com. "Biography—Emma Tenayuca." http://www.latinopia.com/latino-history/emma-tenayuca.

Levine, Dr. Yitzchok. "The Early Jewish Settlement of Texas." http://www.jewishpress.com/sections/magazine/glimpses-ajh/the-early-jewish-settlement-of-texas/2012/02/29/.

Local Legacies. "Texas Rose Festival: A Legacy of Roses." http://lcweb2.loc.gov/diglib/legacies/TX/200003566.html.

McElhaney, Jackie. "The Frankfurt Sisters." *Legacies: A History Journal for Dallas and North Central Texas* (Fall 2003).

McTee, A.R. "Mrs. Anna Hardwick Pennybacker." Texas State Archives, McTee (A.R.) Literary Effort (2-23/958).

Manning, Dan. "Frances Trask: Early Texas Educator." *Southwestern Historical Quarterly* 103 (July 1999–April 2000).

Marchiafava, Louis J. "Dateline: Houston Women Make History at the Polls." *Houston Monthly*, July 1980.

Marshall, Marilyn. "Texas TV Pioneer: Clara McLaughlin Is First Black Woman to Own Stations." *Ebony*, March 1987.

Martin, Douglas. "Henrietta Bell Wells, a Pioneering Debater, Dies at 96." *New York Times*, March 12, 2008.

Masterworks Broadway. "Mary Martin." http://www.masterworksbroadway.com/artist/mary-martin.

Maurizi, Dennis. "Breaking Barriers—The Bessie Coleman Story." *Flight*, August 1998.

Midwestern State University (Wichita Falls, Texas). "MSU News: MSU Professor to Sign Farris Biography at Marker Dedication." http://news.mwsu.edu.

Moffatt, Lori. "Speaking of Texas: A Gift from Mother Neff." *Texas Highways*, January 2010.

National Endowment for the Arts. "NEA National Heritage Fellowships: Lydia Mendoza." http://arts.gov/honors/heritage/fellows/lydia-mendoza.

New York Public Library. "Biographical/Historical Information: Estelle Massey Osborne Papers." http://archives.nypl.org/scm/20749.

Northside Independent School District. "Namesakes: Sandra Day O'Connor High School." http://nisd.net/schools/namesakes/16.

O'Connor House. "Sandra Day O'Connor Biography." http://www.oconnorhouse.org/oconnor/biography.php.

PBS.org. "Mary Martin." Broadway: The American Musical. http://www.pbs.org/wnet/broadway/stars/mary-martin.

Peeler, Tom. "Story of the Store: The Unlikely Marriage of Neiman and Marcus." *D Magazine*, August 1984.

Peterson, Laurie. "Melinda Rankin." http://mchistory.org/research/resources/melinda-rankin.php.

Richardson, T.C. "The Girl Davy Left Behind." *Farm and Ranch*, June 25, 1927.

Rourke, Mary. "Henrietta Bell Wells, 96, Was on 'Great Debate' Team." *Boston Globe*, March 17, 2008.

Rozeff, Norman. "Rosa Maria Hinojosa de Balli: A Modern Woman Before Modern Times." *Valley Morning Star (TX)*, September 11, 2010.

SalsaNet. "Emma Tenayuca." http://www.salsa.net/peace/faces/emma.html.

Shelton, Emily Jones. "Lizzie E. Johnson: A Cattle Queen of Texas." *Southwestern Historical Quarterly* 5 (July 1946–April 1947).

Sivells, Mrs. Wanda Kellar. "'Dr. Mary' Shelman: Pioneer Texas Dentist." *Texas Dental Journal* (July 1980).

Smith, Jerrie Marcus. "Carrie Neiman: Nerves of Steel, Heart of Butter." *Legacies: A History Journal for Dallas and North Central Texas* (Fall 2001).

Stinson, Marjorie. "The Diary of a Country Girl at Flying School." *Aero Digest*, February 1928.

Texas Bankers Association. *Texas Bankers Record*. Vol. 6 (September 1916).

———. *Texas Bankers Record*. Vol. 7 (June 1918).

Texas Highways. "Bronte Literary Club, Victoria." http://www.texashighways.com/travel/item/4381-bronte-literary-club-victoria.

Texas Landmarks & Legacies. "Sharpshooter Plinky Toepperwein Dies in S.A." http://howdyyall.com/Texas/TodaysNews/index.cfm?GetItem=341.

Texas Wesleyan University School of Law. "First Black Female Lawyer in Texas Shares Her Story with Students." *Law News*, March 1, 2005.

Turnage, Sheila. "Claiming the Sky." *American Legacy* (Spring 2000).

United Nations International Criminal Tribunal for the Former Yugoslavia. "Gabrielle Kirk McDonald." http://www.icty.org/sid/155.

University of Alabama School of Nursing. "Mary Louise Roberts Wilson: Remembering the 'Angel of Anzio.'" *Vignette*, 2002.

Untermeyer, Chase. "What Makes Sissy Run?" *Texas Monthly*, April 1974.

U.S. Postal Service. "U.S. Postal Service Launches Music Icons Series with Stamp Honoring Tejano Music Trailblazer Lydia Mendoza." http://about.usps.com/news/national-releases/2013/pr13_053.htm.

van Zelm, Antoinette G. "Van Zelm on Lewis, *Queen of the Confederacy: The Innocent Deceits of Lucy Holcombe Pickens*." https://networks.h-net.org/node/4113/reviews/4678/van-zelm-lewis-queen-confederacy-innocent-deceits-lucy-holcombe-pickens.

Veterans of Foreign Wars. "Women at War: From the Revolutionary War to the Present." July 2011.

Washington County (Texas) Genealogical Society. "Spann Cemetery." http://bluebonnetgenealogy.org/index.php/cemeteries/cemeteries-east/136-aka-old-catholic-aka-sweed.

Watts, Marie W. "Plinky Plinked It!" http://www.schulenburgsticker.com/content/footprints-fayette.

Wooding, James Bennett. "Rebecca Fisher." *Pioneer Magazine of Texas*, May 1922.

BOOKS

American Bankers Association. *Journal of the American Bankers' Association.* Vol. 14 (January 1922).

American Missionary Association. *Annual Report of the American Missionary Association.* Vols. 18, 30–39. New York: American Missionary Association, 1874 and 1884.

Barr, Amelia Edith Huddleston. *All the Days of My Life: An Autobiography.* New York: D. Appleton and Company, 1913.

Biffle, Kent. *A Month of Sundays.* Denton: University of North Texas Press, 1993.

Burns, Chester R. *Saving Lives, Training Caregivers, Making Discoveries: A Centennial History of the University of Texas Medical Branch at Galveston.* Austin: Texas State Historical Association, 2003.

Caplan, Sheri J. *Petticoats and Pinstripes: Portraits of Women in Wall Street's History.* Santa Barbara, CA: Praeger, 2013.

Committee on Un-American Activities, U.S. House of Representatives. *Report on the Congress of American Women.* Washington, D.C.: Government Printing Office, 1950.

Deaf Smith County Historical Society. *The Land and Its People: 1876–1981.* Hereford, TX: Deaf Smith County Historical Society, 1982.

Delta Kappa Gamma Society. *Pioneer Women Teachers of Texas.* N.p.: Delta Kappa Gamma Society, 1958.

Dental Society of the University of Michigan. *The Dental Journal.* Vol. VII. January 1890.

Dixon, Sam Houston. *The Poets and Poetry of Texas: Biographical Sketches of the Poets of Texas.* Austin, TX: Sam H. Dixon & Co., 1885.

Enstam, Elizabeth York. *Women and the Creation of Urban Life: Dallas, Texas, 1843–1920.* College Station: Texas A&M University Press, 1998.

Grider, Sylvia Ann, and Lou Halsell Rodenberger, eds. *Texas Women Writers: A Tradition of Their Own*. College Station: Texas A&M University Press, 1997.

Hammonds, Terry. *Historic Victoria: An Illustrated History*. N.p.: Historical Publishing Network, 1999.

Jackson, Pearl Cashell. *Texas Governors' Wives*. Austin, TX: E.L. Steck, 1915.

Jent, Steven. *Brower's Book of Texas History*. Plano: Republic of Texas Press, 2000.

Johnson, Sid S. *Some Biographies of Old Settlers: Historical, Personal and Reminiscent*. Vol. 1. Tyler, TX: Sid S. Johnson, 1900.

Lasher, Patricia. *Texas Women: Interviews & Images*. Austin, TX: Shoal Creek Publishers, 1980.

LeCompte, Mary Lou. *Cowgirls of the Rodeo: Pioneer Professional Athletes*. N.p.: Illini Books, 2000.

Markle, Donald E. *Spies and Spymasters of the Civil War*. New York: Hippocrene Books, 2004.

Massey, Sara. *Texas Women on the Cattle Trails*. College Station: Texas A&M Press, 2006.

McArthur, Judith N. *Creating the New Woman: The Rise of Southern Women's Progressive Culture in Texas, 1893–1918*. Urbana: University of Illinois Press, 1998.

McCray, W. Patrick. *Keep Watching the Skies!: The Story of Operation Moonwatch and the Dawn of the Space Age*. Princeton, NJ: Princeton University Press, 2008.

McCullough, Joan. *First of All: Significant Firsts by American Women*. New York: Henry Holt & Co., 1980.

McLeRoy, Sherrie S. *Texas Adoption Activist Edna Gladney: A Life and Legacy of Love*. Charleston, SC: The History Press, 2014.

Mullins, Marian Day. *A History of the Woman's Club of Fort Worth, 1923–1973*. Fort Worth, TX: Evans Press, 1973.

Munson, Sammye. *Our Tejano Heroes: Outstanding Mexican-Americans in Texas*. Austin, TX: Panda Books, 1989.

Noriega, Chon A. *Shot in America: Television, the State, and the Rise of Chicano Cinema*. Minneapolis: University of Minnesota Press, 2000.

Paddock, Captain B.B. *History of Texas: Fort Worth and the Texas Northwest Edition*. Vol. 2. Chicago: Lewis Publishing Company, 1922.

Purcell, Mabelle. *Two Texas Female Seminaries*. Wichita Falls, TX: Midwestern University Press, n.d.

Pylant, James, and Sherri Knight. *The Oldest Profession in Texas: Waco's Legal Red Light District*. Stephenville, TX: Jacobus Books, 2011.

Rankin, Melinda. *Texas in 1850*. Boston: Damrell & Moore, 1852.

Robertson, Pauline Durrett, and R.L. Robertson. *Panhandle Pilgrimage: Illustrated Tales Tracing History in the Texas Panhandle*. Amarillo, TX: Paramount Publishing Co., 1978.

Sherrod, Katie, ed. *Grace and Gumption: Stories of Fort Worth Women*. Fort Worth: Texas Christian University Press, 2007.

Silverthorne, Elizabeth, and Geneva Fulgham. *Women Pioneers in Texas Medicine*. College Station: Texas A&M University Press, 1997.

Stafford, Ted. *May Owen, MD*. Austin, TX: Eakin Press, 1990.

The Standard Blue Book of Texas. Vol. 12. San Antonio, TX: A.J. Peeler & Company, 1920.

Sterling, Christopher H., and Cary O'Dell, eds. *Biographical Encyclopedia of American Radio*. New York: Routledge, 2010.

Stuart Female Seminary Catalogue, 1889–1890. Dolph Briscoe Center for American History, Austin, TX.

Taft, J., DDS, ed. *The Dental Register*. Cincinatti, OH: Sam'l A. Crocker & Co., 1899.

Tardy, Mary T. *Living Female Writers of the South*. Philadelphia: Claxton, Remsen & Haffelfinger, 1872.

Texas Federation of Woman's Clubs. *Who's Who of the Womanhood of Texas*. Vol. 1. Austin: Texas Federation of Woman's Clubs, 1923–24.

Texas Mothers Committee. *Worthy Mothers of Texas, 1776–1976*. Belton, TX: Stillhouse Hollow Publishers, 1976.

Texas State Historical Association. *The New Handbook of Texas*. Austin: Texas State Historical Association, 1996.

Turner, Elizabeth Hayes. *Women, Culture, and Community: Religion and Reform in Galveston, 1880–1920*. Oxford, UK: Oxford University Press, 1997.

The University of Texas Medical Branch at Galveston: A Seventy-five Year History by the Faculty and Staff. Austin: University of Texas Press, 1967.

Ware, Susan, ed. *Notable American Women: A Biographical Dictionary Completing the Twentieth Century*. Cambridge, MA: Belknap Press, 2004.

Writers Program of the Works Projects Administration in the State of Texas. *Houston: A History and Guide*. Houston, TX: Anson Jones Press, 1942.

Young, M.J. *Familiar Lessons in Botany with Flora of Texas: Adapted to General Use in the Southern States*. New York: A.S. Barnes & Co., 1873.

CONFERENCE PAPERS

Cannon, Laura. "Brothers at Arms' Length: How Mexican American Business Leaders Handled Labor after the Wagner Act." Texas State Historical Association, March 6, 2014.

Wilcox, Fannie M. "Elizabeth Howard West." Texas State Library staff meeting, November 9, 1952.

ELECTRONIC DATABASES/WEBSITES

About.com. "Women's History." http://womenshistory.about.com.

American National Biography Online. http://www.anb.org.

Austin History Center. "Austin Treasures: Online Exhibits from the Austin History Center." http://www.austinlibrary.com/ahc.

Battle of the Flowers Association. http://www.battleofflowers.org.

Biographical Directory of the United States Congress. http://bioguide.congress.gov.

Chronicling America. http://chroniclingamerica.loc.gov.

Cushing Memorial Library. "Intended for All: 125 Years of Women at Texas A&M." Compiled by Barbara Tinley and Pamela R. Matthews. http://archiveexhibits.library.tamu.edu/womenhistory/.

Dallas Morning News Historical Archive. http://infoweb.newsbank.com.

Dallas Public Library. "Margo Jones, 1913–1955: An Inventory of Her Papers." https://dallaslibrary2.org/texas/archives/06201.html.

Encyclopedia.com. http://www.encyclopedia.com.

Encyclopedia Britannica. http://www.britannica.com.

Encyclopedia of Louisiana: History, Culture and Community. http://www.knowla.org.

Facts on File History Database. http://online.infobaselearning.com.

FindaGrave.com. http://findagrave.com.

GenealogyBank.com. http://www.genealogybank.com/gbnk/.

Goldring/Woldenberg Institute of Southern Jewish Life. http://www.isjl.org.

Google Books. http://books.google.com/.

Google Patents. https://www.google.com/patents.

Great Texas Women. http://www.utexas.edu/gtw/.

Handbook of Texas Online. https://www.tshaonline.org/handbook.

Harry Ransom Center. http://www.hrc.utexas.edu/visit/gwtw.

H-E-B. http://www.heb.com.

HeritageQuest.com. Census records.

Historical Marker Database. http://www.hmdb.org.

Horatio Alger Association. http://www.horatioalger.org/members.

Humanities Texas. http://humanitiestexas.org.

KellyClarkson.com.

Lady Bird Johnson Wildflower Center. http://www.wildflower.org.

Legislative Reference Library of Texas. http://www.lrl.state.tx.us/.

National Cowgirl Museum and Hall of Fame. http://www.cowgirl.net/.

Newspapers.com. http://www.newspapers.com/.

Petticoats & Pistols. http://petticoatsandpistols.com/.

Portal to Texas History. http://texashistory.unt.edu.

Rapoport Center for Human Rights and Justice. "About Frances T. 'Sissy' Farenthold." http://www.utexas.edu/law/centers/humanrights/farenthold/aboutsissy.php.

RootsWeb. http://www.rootsweb.ancestry.com.

Scarlett O'Hardy's Gone with the Wind Museum. http://www.scarlettohardy.com.

Sisters of Divine Providence. http://www.cdptexas.org and http://www.moyecenter.org.

Texas Archival Resources Online. http://www.lib.utexas.edu/taro.

Texas Rose Festival. http://www.texasrosefestival.net.

Texas State Library and Archives Commission. "Votes for Women." https://www.tsl.texas.gov/exhibits/suffrage/index.html.

Texas Tribune "Elected Officials Directory." http://www.texastribune.org/directory.

Texas Woman's University. "Texas Women's Hall of Fame." http://www.tcu.edu/twhf.

Tyler Texas Online. http://www.tylertexasonline.com.

U.S. National Library of Medicine. "Changing the Face of Medicine: Physicians." http://www.nlm.nih.gov/changingthefaceofmedicine/physicians/biography.

U.S. News & World Report. http://usnews.com.

Waco History Project. http://wacohistoryproject.org.

Washington Times. http://www.washingtontimes.com.

Women in Texas History. http://www.womenintexashistory.org.

Women's Professional Rodeo Association. http://www.wpra.com.

EXHIBITS

Austin History Center. "Political Pioneers." http://library.austintexas.gov/ahc/political-pioneers.

GOVERNMENT DOCUMENTS

Alvord, J.W. *Tenth Semi-Annual Report on Schools for Freedmen, July 1, 1870.* Washington, D.C.: Government Printing Office, 1870.

Congressional Record, Volume 149, Number 163. November 11, 2003. Resolution "Congratulating Charlye O. Farris." http://www.gpo.gov/fdsys/pkg.

Texas House of Representatives Resolution No. 86. "Re-designating the Buffalo Herd at Caprock Canyons State Park as the Official State Bison Herd of Texas." June 27, 2011. http://texashistory.unt.edu/ark:/67531/metapth312394/m1/2/?q="Molly Goodnight".

Texas Senate Resolution No. 120. "Commending Charlye O. Farris." October 10, 2003. http://www.legis.state.tx.us/tlodocs/783/billtext/html.

THESES

Smallwood, James M. "Black Texans During Reconstruction, 1865–1874." PhD Thesis, Texas Tech University, 1974.

INDEX

A

Acton State Historic Site 129, 130, 132
Adams, Mollie 94, 95, 166n38
Alamo, the 19, 22, 53, 129, 155, 164n19
Andrews, Jessie 59
Anzio, Italy 124, 125
Armstrong, Anne 90
Arnold, Susan Taylor. *See* Michaelis,
 Aline Triplette
Aunt Lucindy Rainwater 107
Austin, Stephen F. 101, 102
Austin, Texas 36, 45, 46, 53, 81, 82,
 85, 105, 136, 142, 153
Avenger Field 18

B

Barnes Institute 58, 59, 60
Barnes, Sarah 58, 59, 60
Barr, Amelia Huddleston 82, 83, 165n33
Barrera, Aida 35, 36, 67
Battle of the Flowers 22, 23
Baylor University 54, 55, 94, 164n20
Beauchamp, Jenny Bland 156
Beautification Act of 1965 136
Bell, Henrietta. *See* Wells, Henrietta Bell
Bentsen, Lloyd 90, 98

Bickler, Martha Lungkwitz 82, 83
Bilingual Education Act 36, 68
Blossoms in the Dust 159
Boegler, Sister Alfonse 153
Bonnet, Dr. Edith M. 115, 116, 117
Borland, Margaret Heffernan 140, 141
Brackenridge, Eleanor 159
Branch, Mary Elizabeth 68, 69
Briscoe, Dolph 88
Bronte Club 152, 153
Brooks, Dr. Benjy Frances 120, 121
Brownsville, Texas 55, 56
Brown v. the Board of Education 97
buffalo 143, 144
Burks, Amanda Nites 139, 140
Burnett, Carol 31, 33
Butt, Florence Thornton 73, 74

C

Callaway, Isadore 65
Carrascolendas 35, 36
Carter, President Jimmy 38, 89, 98
Caruso, Enrico 26
Case, Viola 152, 153
Castle, Dr. Jessie Estelle 113, 114
Castroville, Texas 153, 154

Chappell Hill 80
Charlie Mary Noble Planetarium 134
Chisholm Trail 139, 140, 169n87
Civil War 41, 42, 56, 57, 58, 82, 106,
 123, 124, 131, 151, 152
Clarkson, Kelly 38, 39
Cluck, Harriet 140
Coleman, Bessie 15, 16, 163n4
Collins, Dr. Florence E. 109
Colquitt, Gov. Oscar 96
Columbian Exposition (1904) 24
Cooper, Madison, Jr. 165n38
Corbitt, Helen 77, 78
Corbitt, Leffler 45, 46
Corpus Christi, Texas 68, 69, 87,
 140, 153
Cravens, Kathryn Cochran 125, 126, 127
Crawford, Mary E. 60, 62
Crockett, David 129, 168n79
Crockett, Elizabeth Patton 129, 130
Cross Plains, Texas 115, 167n64
Cunningham, Henrietta "Hettie" 110

D

daguerrotypes 19
Dallas, Texas 34, 39, 45, 49, 50, 51,
 64, 77, 108, 113, 114, 115, 119,
 124, 125
Daughters of the Republic of Texas
 155, 169n99
Davis, Mollie Moore 105, 106
Davis, Mrs. 19
de Balli, Rosa Maria Hinojosa 137, 139
Debois, Bishop Claude 153
de Juarez, Jovita Idar. *See* Idar, Jovita
Delalondre, Dr. Marie P. 110, 111
de Mireles, Jovita Gonzalez. *See*
 Gonzalez, Jovita
Dickey, Dr. Nancy 121
Dietzel, Dr. Marie Delalondre. *See*
 Delalondre, Dr. Marie P.
Doss Heritage & Culture Center 31

E

Early Birds Club 14
Edna Gladney Home 157, 158, 159
El Congreso Mexicanista 84
Elkins, Jane 93
El Paso, Texas 62, 95, 99
Equal Rights Amendment 88

F

Farenthold, Frances 87
Farmers' Alliance 142
Farris, Charyle O. 97, 98
Feltin, Sister St. Andrew 153
Fence Cutting Wars 106
Ferguson, James 86, 87, 159
Ferguson, Miriam A. 86, 87, 116
Fiesta San Antonio 22, 23
Fisher, Rebecca Gilleland 154, 155
Formby, Margaret 148
Fort Worth, Texas 26, 76, 118, 133,
 138, 148, 157, 158, 159
Frankfurt, Edna, Elsie and Louise 48
Freedmen's Bureau 58, 59, 60

G

Galveston, Texas 23, 49, 58, 59, 60,
 103, 104, 110, 111, 151
Gay Hill, Texas 56, 57
Girls Rodeo Association 144, 145,
 146, 148
Gladney, Edna 157, 158, 159
Gone with the Wind 31, 32, 33
Gonzalez, Jovita 68
Goodnight, Charles 144
Goodnight, Molly Dyer 143, 144,
 150, 169n93
Governor's Mansion 81, 82
Graham, Bette 49, 50
Grand Army of the Republic 124
Great Depression 48, 64, 74, 77
Grelling, Mary John 29

H

Hagman, Larry 30, 31, 34
Haller, Mary Hargrove 80
Halliday, Ebby 50, 51
Harry Ransom Humanities Research
 Center 31, 32
Hayes, Rebecca Henry 159
H-E-B 73, 74
Henderson, Frances Cox 79, 80, 165n32
Henderson, James Pinckney 79, 80
Hernandez, Ruperta Urresta 161
Hickenlooper, Lucy. *See* Samaroff, Olga
Hillsboro, Texas 44, 65
Hispanics, perceptions of 36, 37
Hobby, William P. 159, 161
Holley, Mary Austin 101, 102, 103,
 166n46
hookworms 112, 113
Houston, Texas 23, 33, 37, 49, 53, 66,
 75, 88, 90, 96, 98, 110, 121,
 130, 131
Hubbard, Louis H. 64
Huey, Mary Blagg 71
Huntsville, Texas 43, 55
Huston-Tillotson College 68, 69, 76, 88
Hutchison, Kay Bailey 90, 91
Hutson, Ethel, Mary and Sophie 60, 61

I

Idar, Jovita 83, 84
Independence, Texas 53, 54, 164n20

J

JA Ranch 169n91
Jarmon, Leslie Hope 69
John Sealy Hospital 112, 167n60
Johnson, Lady Bird 135, 136
Jones, Margo 33, 34, 35
Jordan, Barbara 88, 89
Jordan, Martha 113, 114

K

Kerrville, Texas 73, 76
kindergarten 62
Kline, Donna S. 24
Kohlberg, Olga 62
Ku Klux Klan 87, 98

L

Lady Bird Johnson Wildflower
 Center 136
La Liga Femenil Mexicanista 84
Laredo, Texas 83, 84, 161
Library of Congress 85
Liquid Paper® 49, 50
Live Oak Female Seminary 57
Livingston, Texas 20, 33, 35
Locke, Edith W. 95, 96
Lockhart, Texas 88, 89
Lucille B. Smith's Fine Foods 77
Lufkin, Texas 124, 156
Lyons, Lucile Manning 26, 27, 28

M

Maffett, Dr. Minnie Lee 46, 47, 48
Marcus, Carrie 44, 45
Marcus, Stanley 45, 77
Married Women's Property Rights
 Act 96
Marshall, Texas 41, 66, 80
Martin, Mary 30, 31, 163n11
Mazeppa, or the Wild Horse of Tartary
 20, 22
McCain, John 90
McDonald, Gabrielle Kirk 98, 99,
 166n42
McGovern, George 88
McMillan-Herod, Anyika 93
Mendoza, Lydia 36, 37, 38
Menken, Ada(h) Isaacs 20, 21, 22
Mexican-American War 55, 168n85
Mexican Revolution 37, 83, 161
Mexico 38, 53, 55, 56, 84, 137, 139

Michaelis, Aline Triplette 108
Morris, Reverend I.Z.T. 157
Morton, Azie Taylor 88, 89, 90
Mother Neff State Park 131, 132, 133
Mothers' Pension Bill 108
Mueller, Rudolph 153, 154

N

National Cowgirl Museum and Hall of
 Fame 100, 148, 149, 150
Native Plant Information Network 136
Neff, Isabella Shepherd 131, 132
Neff, Pat 132, 133
Neiman Marcus 44, 45, 77
Nesmith, Michael 50
New History of Texas, A 104, 105
newspapers
 Daily Ardmorite 107
 Dallas Herald 103
 El Paso Herald 95
 El Progreso 84
 Frank Leslie's Illustrated Weekly 142
 Houston Post 96
 Houston Telegraph 106, 131
 La Cronica 83, 84, 165n36
 Milwaukee Journal 26
 New York Evening Post 24
 San Antonio Light 49
 Sherman Courier 107
 Texas Mesquiter 107
 Texas Ranger 20
 The Free Lance 108
 Tyler Reporter 106
Nineteenth Amendment 161
Noble, Charlie Mary 71, 133, 134
Nueces River 168n85

O

Oakley, Annie 25, 26
O'Connor, Sandra Day 99, 100, 150,
 166n44
O'Daniel, W. Lee "Pappy" 87
O'Hara, Scarlett 31, 32, 33

Osborne, Estelle Massey Riddle 117, 118
Osterman, Rosanna Dyer 151, 152
Owen, Dr. May 118, 119, 120, 150
Owens, Margaret 145, 146

P

Page Boy Maternity Clothes 48
Palo Duro Canyon 144
Parent-Teacher Association 65
Paris Conservatoire de Musique 23
Paris, Texas 155, 156
Parker, Lulu 71
Pease, Elisha 81, 82
Pease, Lucadia Niles 81, 82
pecan shellers strike 74, 164n27
Pennybacker, Anna 104, 105
Pickens, Lucy Holcombe 41, 42
Porter, Ella Caruthers 65, 66
Prairie View A&M University 76, 97, 117
Press Women of Texas 49
Professional Rodeo Cowboy
 Association 146
Purcell-Burkland, Tami 146, 147

R

Rankin, Melinda 55, 56
Reader's Digest 49
Reagan, John H. 93
Reagan, President Ronald 100
Red, Rebecca Stuart 56, 57
Remember the Alamo 82
Richards, Ann 71, 91
Riddle, Lena 45
Rio Grande 137, 139, 168n85
Rio Grande Female Institute 55, 56
Rio Grande Valley 36, 67, 137,
 169n86
Rockwall County Historical
 Foundation 113
Rodenberger, Lou Halsell 48
Rodgers & Hammerstein 31
Runaway Scrape, The 53, 140, 164n19
Rusk, Thomas J. 90

S

Samaroff, Olga 23, 24
Sam Houston State University 43, 104
San Antonio, Texas 13, 15, 20, 22, 23, 26, 38, 67, 68, 74, 75, 84, 85, 98, 112, 117, 153, 161
San Jacinto, Battle of 22, 53, 103
Scarlett O'Hardy's Gone with the Wind Museum 33
Schaefer, Dr. Marie Charlotte 112, 113
Scott, Dr. Gloria 160
Seelye, Emma Edmundson 123, 124, 168n72
Selznick, David O. 32
Shelman, Dr. Mary Lou 114, 115, 167n64
Sherman, Texas 107, 157
Silver Star 125, 168n75
Sisters of Divine Providence 153, 154, 169n96
Skinner, Sarah 59
slavery 93, 104
Slayden, Ellen 22
Smith, Lucille Bishop 75, 76, 77
Smoots, Mary Winn 107, 108, 167n54
Sorosis Club 152
Spann, Mrs. Eleanor 103, 104
Sthreshley, Elizabeth 43, 44
Stinson, Katherine 13
Stinson, Marjorie 13, 14, 15
Stokowski, Leopold 24
Strauss, Robert 89
Stuart Female Seminary 57

T

Temple B'nai Israel 152
Tenayuca, Emma 74, 75, 164n26
Texas A&M University 60, 61, 62
Texas Children's Home and Aid Society 157, 158, 159
Texas Congress of Mothers 65, 66
Texas Dental Journal 167n61

Texas Federation of Business & Professional Women 46, 47, 48
Texas Federation of Music Clubs 26, 27
Texas Folklore Society 68
Texas Horse Racing Hall of Fame 147
Texas Institution for the Blind 43, 44
Texas Legislature 64, 81, 96, 105, 108, 133, 161
Texas Rangers 84
Texas Rose Festival 28, 29
Texas Tech University 85, 119
Texas Veterans Association 155, 169n99
Texas Woman's University 33, 35, 63, 64, 71
Texas Women's Banking Association 45, 46
Texian Monthly Magazine 103, 104
Thompson, Frances Trask 53, 54, 55
Toepperwein, Adolph 24, 26
Toepperwein, Elizabeth "Plinky" 24, 25, 26
Tolson, Melvin 66
Townsend, Elizabeth Sthreshley. See Elizabeth Sthreshley
Tucker, Ella Isabella 64
Turner, Adella Kelsey 64
Tyler, Texas 28, 104, 106

U

United States Supreme Court 96, 99, 100
University of Michigan 66, 113
University of Texas 33, 57, 59, 69, 77, 87, 90, 91, 110, 136
University of Texas Medical Branch 110, 111, 112, 113, 115

V

Van Zandt, Dr. Frances 115, 116, 167n67
Victoria Literary Society 152

W

Waco, Texas 55, 94, 95, 165n38
Ward, Hortense Malsch 96, 97, 150
Washington, Denzel 66
Weatherford, Texas 30, 31, 144
Wells, Henrietta Bell 66
Werlin, Rosella Horowitz 49
West, Elizabeth Howard 84, 85
Wichita Falls, Texas 97, 98
Wiley College 66
Willard, Frances 155, 156
Williams, "Lizzie" Johnson 140, 141
Wilson, Mary Louise Roberts 124, 125
Wire Cutters, The 105, 106
Woman's Christian Temperance Union
 65, 155, 156, 157
Woman's Collection, The. *See* Texas
 Woman's University
Women's Airforce Service Pilots
 (WASP) 17, 18, 64
Women's Professional Rodeo
 Association 144, 145, 146
women's suffrage 96, 156, 157, 160, 161
women's suffrage 97, 159
World War I 13, 46, 95
World War II 17, 18, 38, 48, 117, 124,
 125, 127, 134
Wright, Orville and Wilbur 13

Y

yellow fever 60, 103, 104, 110, 130,
 140, 151, 152
Young, Maud Fuller 130, 131

ABOUT THE AUTHOR

S herrie S. McLeRoy received a BA in history/anthropology with high honors in anthropology from Sweet Briar College and is a 1976 graduate of the Williamsburg (Virginia) Seminar for Historical Administrators. Her first career, from 1974 to 1988, was as a museum administrator and curator in her native Virginia and in Texas. Since then, she has been a writer, speaker and independent historical scholar. She has written or contributed to more than twenty books on the histories of Texas and Virginia. Among them is *Grape Man of Texas: Thomas Volney Munson and the Origins of American Viticulture*, which has won two "best of" awards from the Gourmand World Cookbook Awards in Madrid, Spain. She is a member of the Southern Historical Association, the Southern Association of Women Historians and the Western Association of Women Historians.

Visit us at
www.historypress.net
...
This title is also available as an e-book